BRUSHED VOICES:
CALLIGRAPHY IN CONTEMPORARY CHINA

by Yiguo Zhang

MIRIAM & IRA D. WALLACH ART GALLERY

COLUMBIA UNIVERSITY

1998

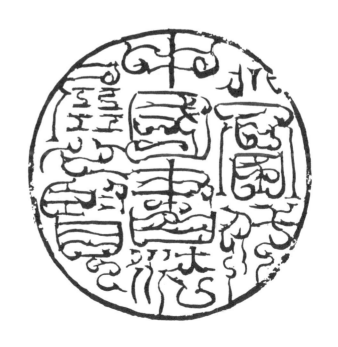

This publication is issued in conjunction with the exhibition
Brushed Voices: Calligraphy in Contemporary China
held at the
Miriam and Ira D. Wallach Art Gallery,
Columbia University in the City of New York,
15 April to 6 June 1998.

Published by the Miriam and Ira D. Wallach Art Gallery, Columbia University in
the City of New York

Poems reprinted courtesy Beijing University Press (p. 105), Columbia University
Press (p. 42), Foreign Language Press, Beijing (pp. 46–47, 89), Indo-Chinese Litera-
ture Publications (p. 81), Oxford University Press (p. 80), and Shanghai Chinese
Classics Publishing House (pp. 52, 69)

Library of Congress Catalog Card Number 98-065673
ISBN 1-884919-06-5

Distributed by the University of Washington Press, Seattle

Seal on title page, *Calligraphy in Contemporary China*, cut by Han Tianheng

TABLE OF CONTENTS

FOREWORD

The art of writing has been a central component of Chinese culture for several millennia. Indeed, one might trace the history of that culture—its political and military, religious and social vicissitudes—in the history of the art, in the development of its scripts and the cycles of their styles. From their origins as systems of ideograms through the successive inventions of seal, clerical, standard, and cursive scripts to the energetic extensions of running and wild cursive, writing systems in China have offered a particular barometer of social and individual pressure. Within the accumulated experience of the art over centuries each innovation in writing style seems to reflect deeper societal concerns, even as it is read as the expression of an individual calligrapher. Against standard or clerical script, its structural stability fully consonant with its monumental and public function, the creation of a running or cursive style, tracing a willful individualism, could seem a challenge to the social order, an assertion of the personal and the private. The practice of calligraphy itself is founded in a deep historical self-consciousness; spontaneous personal expression could be achieved only through dialogue with the masters and models of the past. To write with the brush was to participate in history, whether with or against the venerable past of the art. It is precisely such creative tensions—between past and present, tradition and innovation, social convention and individual spontaneity—that invest calligraphy with its special charge.

Those same tensions lend special relevance to this exhibition of calligraphy in contemporary China. As Yiguo Zhang describes in his introductory essay, calligraphy is flourishing in China today, with a popularity that challenges its traditional status as an art of the elite. This art of writing, an art developed over time as a means of profoundly personal expression, has been appropriated by new segments of society; the new calligraphers represent a broad social range, from farmers and workers to academics and professional artists—and that range is represented in the present exhibition. Calligraphy has again become a major art of self-expression in China.

Although the history of the art includes calligraphers in the service of the state, from government officials to emperors, that history seems especially animated by mas-

ters of the brush outside the court, officials in exile, whether mandated or self-imposed. The voice of protest or criticism, so often couched in an indirect vocabulary of metaphor or poetic allusion, found its fullness of expression in the very act of writing, in the traces of the brush. It is the brush that speaks.

"Le style c'est l'homme": Although speaking for European connoisseurship in the eighteenth century, Buffon expressed an axiomatic assumption that transcends its particular culture. In Greek antiquity the painter Apelles was recognized by a single stroke of the brush. That the mark of the artist represents the person, reveals his or her character, is a principle even more fundamental to the art of the brush in China. And because individual expression, no matter how radical, takes shape within the controlling contexts of an established vocabulary of forms, it is constantly measuring itself and being measured against the accumulated history of its predecessors.

For a Western audience the characters of Chinese writing may indeed remain undecipherable, the texts illegible. But we can and do respond to the spirit of the brush, to the expressive qualities of each stroke and to the dynamics of formal construction. We follow the energies of the brush, move with its speed, adjust to its turns; we willingly accept the spatial implications of "flying white," as the brush dries and its split and scattered traces seem to dissipate into the openness of the paper. In allowing our eyes and our bodies to follow the lead of the brush, we engage the impulses and decisions of the calligrapher; through our response we reimagine the creative acts and thereby participate in the art of writing. Purely linguistic barriers fall away as we read the expressive gestures. *Brushed Voices: Calligraphy in Contemporary China* offers a welcome occasion to demonstrate the possibilities of such visual communication, an invitation to participate in the art of writing.

Yiguo Zhang, an accomplished calligrapher himself, assumes that fundamental accessiblity of the Chinese art of writing. The project of presenting the work of contemporary calligraphers, to demonstrate the renewed vitality of the art, grew from discussions of the mark of the artist and the similar meanings assigned to such marks by cultures that value the presence of the artist in the work. In his own research on traditional Chinese painting and calligraphy, Mr. Zhang has been developing new critical perspectives through the recognition of that shared phenomenology of response.

Brushed Voices is the second major exhibition of the Wallach Art Gallery devoted to Chinese art; the first, in 1993, was *"O Soul Come Back!" The World of the Han Dynasty Tomb*, organized by Professor David Sensabaugh, now curator of Asian art at the Yale University Art Gallery. We are grateful to him for his crucial role in the genesis of the project on contemporary calligraphy—and I personally for his encourage-

ment of an amateur like myself. These exhibitions contribute significantly toward the enrichment and expansion of the program in Chinese art history at Columbia. I am also happy to acknowledge the energetic commitment of our new colleague Professor Robert Harrist, Jr., to the program and the exhibition. Finally, I extend my personal gratitude to Professor Wen Fong of Princeton University for his continuing encouragement and wise counsel, as well as for informal instruction in the history of calligraphy.

The program of the Miriam and Ira D. Wallach Art Gallery is designed to encourage students in the Department of Art History and Archaeology to develop exhibitions growing out of their own special interests. Mr. Zhang's research and travel for *Brushed Voices: Calligraphy in Contemporary China* was made possible by a Wallach Art Gallery Fellowship, and we continue to be grateful to Mr. and Mrs. Wallach for their inspired support of the gallery's program. That program and the exhibitions owe their successful realization to Sarah Elliston Weiner, director of the Wallach Art Gallery, and to her staff: Jeanette Silverthorne, curatorial assistant, who demonstrated particular skill in setting the Chinese text; Benita Dace, administrative assistant; and Lawrence Soucy, technical coordinator, with whom it is always a pleasure to hang a show.

David Rosand
Meyer Schapiro Professor of Art History
Chairman, Miriam and Ira D. Wallach Art Gallery

ACKNOWLEDGMENTS

To the twenty-one artists who have entrusted their work to us for inclusion in this exhibition goes our deepest gratitude. Most of them are showing their work in the United States for the first time, and the Wallach Art Gallery is honored to have this privilege. One of the artists, Liu Zhengcheng, was extremely supportive and helped to facilitate many details of the loans. Han Tianheng merits particular thanks for cutting the seal, *Calligraphy in Contemporary China*, that appears on the title page. To the American artist Brice Marden, our heartfelt thanks for sharing with Yiguo Zhang his thoughts about his own work and its relation to Chinese calligraphy and for allowing us to publish the interview.

During the course of his research and the preparations for this exhibition, Yiguo Zhang has benefited from the generous help of numerous friends and advisers. Discussion with many faculty members at Columbia have shaped the ideas that animate this project. Among them are Professors Wen-chung Chou, Robert Harrist, Jr., David Sensabaugh (now of the Yale University Art Gallery), and especially David Rosand, who has offered methodological instruction and ardent encouragement. Alex Beels and Harry Miller translated some of the texts and provided invaluable assistance with other translations from the Chinese as did Professors Wei Shang, David Wang, and Pei-yi Wu. Jinglun Zhao's comments greatly improved the Chinese text. Others who read and commented on early versions of the catalogue text include Adrienne Baxter, Susan Greenwell, Lou Rouse, Anthony Scibilia, Shan-hong Shen (formerly of City University), Xiaoju Wang, Hailing Yi, and Hansun Zhang. Finally, particular thanks go to David Willson, a devoted friend of Chinese calligraphy and a true collaborator in this project.

Extraordinary efforts by several people underlie this project. The photographers Dwight Primiano and Yan Wang were particularly obliging. Zhihua Wang mounted most of the works in the exhibition. Working with Jerry Kelly and his colleagues at The Stinehour Press is always a pleasure; our sincere thanks to them for another splendid catalogue.

The generous contributions of a group of donors, persuaded of the importance of introducing new ideas in Chinese calligraphy to a broader audience, has allowed the realization of this exhibition and its catalogue. We are especially appreciative of the gifts made by Mr. and Mrs. John Curtis, Jessie M. Kelly, the B. Y. Lam Foundation, H. Christopher Luce, Lillian Schloss, the Eugene V. and Clare E. Thaw Charitable Trust, and anonymous donors. Raphael Bernstein has become a special friend of the gallery, and we are deeply grateful for his continuing encouragement and support. Gordon Bennett, a long-time friend of Yiguo Zhang's, has shared Yiguo's enthusiasm for the project as well as making a significant contribution to ensure its success.

Sarah Elliston Weiner
Director, Miriam and Ira D. Wallach Art Gallery

THE NEW CULTURE OF CALLIGRAPHY

Recent trends in Chinese calligraphy include developments that are unprecedented in the history of this most traditional art. Originally a high art enjoyed only by literati and officials, calligraphy has come to be enjoyed by a broader social spectrum—a phenomenon that reflects recent social changes in China itself. This new popularity of a traditional Chinese art form is somewhat ironic when one considers the prevalence of Western influence in China today. While the resurgence of Chinese painting and literature may have slowed during the last several years, the passion for calligraphy continues unabated. Indeed, it may now be considered a popular art. Recent practice in calligraphy, reflecting new social realities in China itself, requires a revision of traditional critical approaches to the art, approaches closer to a contemporary aesthetics; the new art may demand a new critical language.

A NEW SOCIAL PHENOMENON

During the past decade the number of calligraphy exhibitions and competitions has vastly increased. Today, local, national, and even international exhibitions can be seen throughout China. The participants, ranging from five-year-olds to centenarians, can number in the tens of thousands. One calligraphy competition, sponsored by the American collector Jill Sackler and held every two years since 1990, is part of this development. More than 10,000 entries were submitted in its first year. Of these, 3,400 works were submitted by individuals over 35 years old, 6,000 by people between 18 and 35 years of age, and 1,000 by children. The participants came from a broad range of social and economic classes and included industrial workers, peasants, officials, teachers, professional artists, soldiers, and even prisoners.[1]

Most calligraphy exhibitions are sponsored by newspapers, companies, or art associations. Sponsors usually invite famous calligraphers to judge the entries, and prize money can range from hundreds to thousands of Chinese yuan.[2] Acknowledging calligraphy's ancient tradition, awards in these competitions are frequently named after venerable calligraphers, such as the Wang Xizhi (A.D. 306–361) Cup or the Ouyang Xun (A.D. 557–641) Cup.

The largest and most important exhibitions are the National Calligraphy Exhibition and the National Exhibition of Middle-Aged and Young Calligraphers. Held every two years, both are sponsored by the Chinese Calligraphers' Association (CCA) and are open to all. The exhibitions department of the association chooses an evaluation committee from among well-known critics and artists. Having work accepted is difficult; only 20 percent of the submissions are chosen for final judging. Winning is even more difficult—even famous calligraphers rarely win—and few people are awarded prizes twice in a row. Participants might practice for several months or even a year to produce a single piece of calligraphy, using more than a thousand sheets of paper in the process. Furthermore, the criteria for evaluation at these two recent exhibitions have become increasingly stringent. Three main criteria are applied: 1) contents should be neither lewd nor pornographic; 2) the work must display traditional expressive skills, demonstrating a certain foundation, and individual style should have definite artistic power; 3) the work cannot be imitative of the styles of other contemporary calligraphers.[3]

Exhibitions are often organized for special occasions and incorporated in broader social projects or concerns. For example, during the United Nations Women's Conference in 1995, some provinces held exhibitions of calligraphy by women. At another time, an exhibition was held to raise funds for the victims in a disaster area.

A related development is a marked increase in the number and circulation of publications, indicative of the popularity of all types of calligraphy. Although major newspapers, such as the *Renmin Ribao* (People's Daily) and *Zhongguo Qingnian Bao* (China Youth Daily), publish special columns devoted to contemporary calligraphy, they cannot satisfy the overwhelming interest in the art. Consequently, many new professional calligraphic newspapers and magazines, such as *Shufa Yanjiu* (Calligraphy Study) and *Shufa* (Calligraphy) (first published in Shanghai in 1979), have appeared. The newspaper *Shufa Bao* (Calligraphy) (not associated with the magazine of the same name), which is usually prompt to announce calligraphic exhibitions and research, began publication in Hubei Province in 1984. *Zhongguo Shuhua Bao* (China Calligraphy and Painting) began in Tianjin in 1982 and emphasizes the teaching of calligraphy, especially to children. *Zhongguo Shufa* (Chinese Calligraphy), published by the Chinese Calligraphers' Association, began in 1982. Currently issued every two months, it will become a monthly this year, and is considered the preeminent calligraphy magazine.

A further development is educational and is evident in the establishment of many new calligraphy organizations. The most prestigious is the Chinese Calligraphers' Association, established in 1981. Ten years later, it had more than 3,000 members of whom 200 were women; senior citizens and youths comprised 60 percent of the total. Currently, there is a branch in every province, with a combined membership

of approximately 30,000.⁴ In addition to the CCA, there are numerous other calligraphy organizations throughout China. Many factories, for instance, have their own calligraphy clubs, where employees spend their leisure time practicing calligraphy. Indeed, many professional calligraphers began as blue- or white-collar workers. The coal-mining industry sponsors a large calligraphy club, whose first president was Zhang Chao, the vice-minister of the Ministry of Coal Mines. The celebrated calligraphers Wu Xing and Chen Haojin both started as coal miners.⁵ During the past nine years, the development of such industry-based clubs has flourished. Today approximately four hundred small clubs, with thousands of participants contribute to a vibrant, calligraphy-nurturing system. Some members, having developed their calligraphic skills within this system, have subsequently gone on to universities to continue their study of calligraphy.

While such organizations provide an opportunity to learn calligraphy, professional study in an art school or university is another option. Some cities have special schools, such as the Institute for Advanced Calligraphy Study, established in Qingdao in 1994. Fifteen years ago, no school had a calligraphy department, but now most have established them. Although some aspiring calligraphers still follow the traditional apprentice method, learning from an individual master, many now pursue an academic course of study. The Chinese Academy of Fine Arts in Zhejiang Province produced the first generation of graduate students majoring in calligraphy, among them Wang Dongling (CAT. 41–45), Zhu Guantian, and Chen Zhenlian, all of whom are now well established. Ouyang Zhongshi (CAT. 25–26), a professor at Capital Normal University, was the first to train Ph.D. students in calligraphy. Professor Ouyang prepares students both as scholars and as artists, for academic careers and artistic practice. Some of his calligraphy students have gone on to highly successful careers; two of them, Liu Wenhua (CAT. 17) and Wang Youyi (CAT. 52–54), are included this exhibition.

While many calligraphers achieve renown only when they reach middle age, they usually began practicing calligraphy when they were very young. Early education is necessary to nurture young calligraphers. Beijing and many other cities have cultural centers for children where calligraphy is taught. Competitions are organized to encourage these children, who are often touted by sponsors and newspapers as "infant prodigies." Moreover, the National Education Committee has established a working group to produce a calligraphy textbook for pupils through the ninth-grade level.⁶

What accounts for this widespread and democratic interest in calligraphy and its practice? Most people see calligraphy as a symbol of traditional Chinese culture. The average Chinese person may not know about the Tang emperor Taizong (A.D. 597–649), but he or she is certainly familiar with Wang Xizhi, the fourth-century "sage" of calligraphy. In addition, some people think of practicing calligraphy as a kind of spiri-

tual exercise or meditation. The elderly are often particularly eager to participate in calligraphy activities and exhibitions, just for the pleasure of being able to show their work in public. Many young people, however, want to excel at calligraphy in order to achieve renown and a comfortable living. Winning a prize in an important exhibition elevates one's social status and can lead to a good position at a cultural center. Further, while only ten years ago few people thought of earning a living by selling their calligraphy, today there is a well-established market for such art work. Clearly, attitudes have changed.

In the 1950s, a painting by Qi Baishi (1863–1957) sold for only four to six yuan per foot. In today's market, the same work would fetch several million, far beyond the purchasing power of most people. Although only a few wealthy Chinese can afford to acquire such works, the average buyer is willing to spend up to five hundred yuan (approximately $60) for a single piece. Recently, auctions have become popular. Among the major auction houses are Jiade (China Guardian), Beijing Hanhai, Shanghai Duoyun, and Tianjin Auction. In the spring of 1995, China Guardian held a particularly successful sale in the Great Wall Hotel in Beijing. About five hundred collectors, connoisseurs, and businesspeople came from around the world. Three hundred and sixty-six works of Chinese painting and calligraphy were offered for sale. In seven hours 70 percent of them (including sixty works of calligraphy) were sold for a total of 31 million yuan (about $3.7 million).[7]

The growing market and commerce in calligraphy is not without problems, however. For example, *Chairman Mao Bombards the Headquarters*, a work ascribed to Wu Guanzhong, which sold at the Shanghai Duoyun auction in 1995, was exposed by the artist himself as a fake. Another problem is price. In order to show a work's "value," painters and calligraphers often refuse to lower their prices for domestic collectors, fearing that to do so would affect prices in the foreign market. Artists are usually salaried teachers in art schools and selling their works provides a supplementary income. As in the United States, budget cuts have forced many leading art schools to cut faculty, and artists now must rely on selling their work to earn a living.

In sum, exhibitions, newspapers, magazines, organizations, formal education, and the market have undoubtedly stimulated the present florescence of calligraphy. This system of competition, education, and exchange has provided a context for the development of calligraphy. Actual changes in calligraphic practice, however, can best be seen by examining the works themselves.

Before analyzing contemporary calligraphy, the definitions and relationships of calligraphic elements should be clarified. Brushwork, construction of characters, application of ink, composition, and rhythm are the five basic elements in all calligraphy work (FIG. I). *Brushwork* denotes the way the brush is held and the effect of its application to paper, the most important feature being its movement. Brushwork can be described in contrasting terms: fast or slow, light or heavy, square or round, sharp or blunt, and so on. *Centered-tip brushwork*, for instance, refers to holding the brush so that the tip stays at the center of the stroke being drawn, while *slanted-tip brushwork* refers to holding the brush so that the tip runs along the edge of the stroke. *Construction* denotes the form and structure of individual characters as manifest in spatial terms. *Application of ink* is the density of ink at any point in a work. Brushwork, construction, and application of ink together constitute the main elements of *composition*: the overall arrangement of the entire work. *Rhythm* refers to the changes in speed and weight produced in the calligraphic line as it is drawn. Rhythm is mainly a function of brushwork and the application of ink, although sometimes the construction of the characters also contributes to a sense of rhythm. Brushwork and construction are the basic categories in traditional criticism.[8]

Trends in contemporary calligraphy follow two general directions. The first is marked by the revitalization of traditional methods. Works of this type are concerned with the exploration and rediscovery of classic works and styles. The second trend is so-called modern calligraphy (*xiandai shufa*), which departs radically from traditional methods.

One of the most important developments in the contemporary practice of traditional calligraphy has been the tendency to introduce an increasing number of cursive elements into all script types. This trend has been noted in recent years by critics at the major calligraphy exhibitions, such as the Fifth National Calligraphy Exhibition in 1992. There, the prevalence of cursive techniques led critics to note that the speed of brushwork was faster than that seen in any previous exhibition.

In addition to speed of execution, cursive script is characterized by great freedom in brushwork, construction, application of ink, rhythm, and composition. "Flying

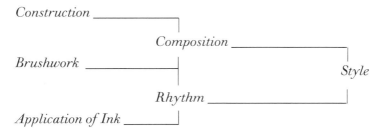

FIG. I *Diagram of the elements and relationships of calligraphy (author)*

FIG. I

white" strokes executed at high speed are characteristic of cursive brushwork.9 The construction of individual characters is simpler than in standard or running script. Two strokes may merge into one, or three twisting lines may be reduced to two curves. Within a single work, ink may be applied with both wet and dry strokes, producing a three-dimensional effect. The rhythm of cursive script is vivid and the movement of its lines is more flowing, its momentum stronger than in any other type of calligraphy. The composition of the entire work is achieved by arranging its elements in clear contrasts, such as big versus small, inclined versus upright, heavy versus light, dry versus moist. For these reasons, cursive script is the most complex, synthetic, and expressive type of calligraphy. The following examples which incorporate cursive style with different types of calligraphy show the ways in which some contemporary calligraphers are departing from historical practices.

FIG. II *Oracle bone script (ca. 1334–1275 B.C.)*

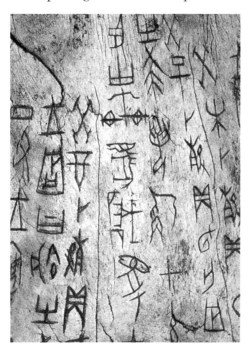

FIG. II

Wang Youyi's oracle bone script (*jiagu wen*), for instance, is a good example of the influence of cursive brushwork on contemporary practitioners of ancient calligraphic types (FIG. II; see also CAT. 52–54). Oracle bone, a type of seal script, is the earliest known Chinese writing, originating in the Shang Dynasty (ca. 1600–ca. 1100 B.C.). Its name derives from its use in inscribing the results of divinations on tortoise shells and ox bones. Generally, the defining characteristic of oracle bone script is the straight and smooth line made by the knife. There is no embellishment of the beginning or the chief part of the stroke, which produces characters of well-balanced structure. Wang Youyi believes that when writing oracle bone script

FIG. III *Di (oracle bone script), by Luo Zhenyu*

FIG. IV *Ma, from Stone Drum (ca. 770–766 B.C.)*

with a brush on paper, calligraphers such as Luo Zhenyu (1865–1940) (FIG. III) consciously constructed their lines as if they were inscribing the characters with a knife, in order to attain the beautiful solidity and strength typical of good oracle bone script. Although Wang used to follow this style himself, he has since come to think that Luo's approach neglected the expressive possibilities of the brush. Influenced by his study of the

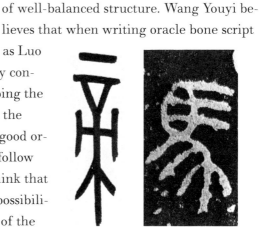
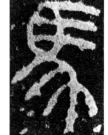

FIG. III FIG. IV

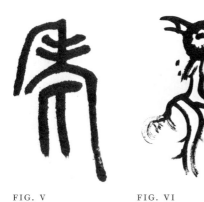

FIG. V FIG. VI

Stone Drum, an inscribed stone produced during the Zhou Dynasty (ca. 1100–256 B.C.) (FIG. IV), Wang began to replace the straight strokes he had previously favored with curved lines, which, despite an apparent weakness, nevertheless convey a distinctly solid and confident effect.

FIG. V *Lao (seal script), by Deng Shiru (1743–1805)*

FIG. VI *Ji (cat. 53, detail)*

Wang also believes nineteenth-century calligraphers overemphasized centered-tip brushwork (FIG. V). In contrast, he combines centered- with slanted-tip brushwork. He loads his brush with ink and alternates between fast and slow strokes. As the moist ink diffuses into dark shapes and the dry brush produces "flying white," each character is varied. Wang's brushwork is unlike that seen in Qing Dynasty (1644–1911) seal script calligraphy, in which strokes begin with a reverse motion of the brush and are continued by dragging the brush at an even pace. Instead, Wang twists his lines with the rise and fall of his brush. In making turns, he traces a flickering line, which produces a combination of square and round forms that enhances its flavor (FIG. VI). The result is Wang's own cursivelike brushwork, distinctly different from the historical calligraphy that inspired it.[10]

Clerical script (*lishu*), the second oldest type of calligraphy, appeared during the Han Dynasty (206 B.C.–A.D. 226) (FIG. VII). One category of clerical script, that written on bamboo strips, it has become a favorite source for modern calligraphers. In clerical script the outline of each character is generally a low rectangular shape; the edges of the stroke are squared off, particularly at the beginning, and turns are angular, composed of straight lines.

Han bamboo strips exhibit a great variety of expressive elements, including freely applied gestures, uneven shapes, and cursive brushwork. Fluid and lively, most of these bamboo strips were written by common people, or anonymous artists, and contain elements that professional

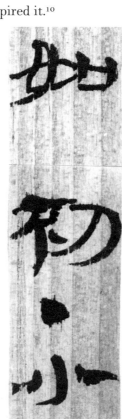

FIG. VII *Bamboo strip (ca. 206 B.C. –A.D. 9)*

FIG. VII

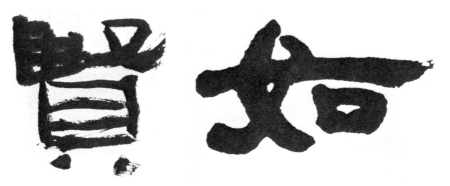

FIG. VIII

FIG. IX

calligraphers have recently come to admire for their naïveté, austerity, and innocence. With their freedom, liveliness, and constant search for expressive form, Han bamboo strips have a special appeal for the modern artist.

Their influence is readily observable in the cursive tendencies of Liu Wenhua's clerical script, for which he has won several national prizes. *Ode to History* (CAT. 17) won a prize at the Fourth National Calligraphy Exhibition in 1989. Four strips of paper, suggesting bamboo strips, form the background of the characters. The bold expanding stroke of *xian* (good statesmen), the fourth character in the first column (FIG. VIII), still retains the style of the Han bamboo strips. The brush moves vividly, trembles subtly, yet seems to flow less artificially than often found in Qing Dynasty clerical script, such as that of that of Deng Shiru (1743–1805) (FIG. IX). In composition, some characters exhibit dry lines in the cursive method, where the ink seems to disappear at the end of a stroke and appear again, such as in the character *qi* (why) (FIG. X). This cursive quality is rarely seen in historical clerical script. Handling the brush in this way is very difficult, and Liu's cursive technique shows great proficiency. Alternating between dry and wet characters not only creates a spatial effect but also produces a rise and fall of strong, accented rhythms.

The same cursive tendency can be seen in standard script (*kaishu*). Sun Boxiang is a specialist in the style of Northern Wei stele inscription, a branch of standard calligraphy (see CAT. 33). This script style was originally used to engrave inscriptions on stone during the Northern Wei Dynasty (A.D. 386–535). The main feature of this calligraphy lies in its unique brushwork, solid and square; its strokes create a majestic and powerful expression, while the shapes of the characters are relatively uniform (FIG. XI).

FIG. X *Qi (cat. 17, detail)*

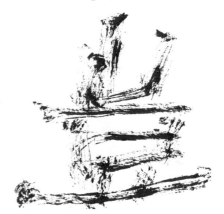

FIG. X

Stele calligraphy became popular during the late Qing Dynasty. The Qing calligraphers Zhao Zhiqian (1829–1884) and Li Ruiqing (1867–1920) avidly studied ancient inscriptions (FIGS. XII–XIII). Yet their brushwork, construction, rhythm, and especially their composition lack the dynamism and variability that is important for stele calligraphy. Both Zhao's brushwork and the square construction of his individual characters are repetitive; Li's

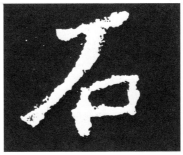

FIG. XI

FIG. XI *Shi, from Cuan Longyan (A.D. 458)*

artificially shaking stroke is devoid of vivid movement.[11] Because of this dull brushwork, the ancient majestic spirit is lost. Contemporary calligraphers who study stelae, such as Sun Boxiang, have analyzed Qing approaches and aim for a new understanding. Sun's work shows more freedom of style than that of Zhao and Li. In addition, the strength and grandeur of the original Northern Wei calligraphy and cursive script are matched by the contemporary disciple.

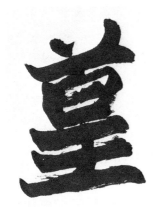

FIG. XII FIG. XIII

Sun's brushwork is still based on the original solid square shape of Northern Wei calligraphy. It combines sharp points and round strokes, most obviously at the beginning of the stroke (FIG. XIV). His composition, however, shows distinct cursive tendencies. In *Couplet* of 1986

FIG. XII *Huang (standard script), by Zhao Zhiqian*

FIG. XIII *Kong (standard script), by Li Ruiqing*

(CAT. 34), the third character, *qiang*, is thin and its right side inclines to the left; while the following character, *ming*, is thicker with its left component tending toward the left side. The sixth character, *zhong*, is remarkably different from the previous characters: small and composed of sharply contrasting slim and heavy strokes, its outline is so animated that it adds a sense of variation and liveliness to the solemnity of the characters that precede and follow it. By presenting his strokes in contrasted forms—long versus short, slim versus heavy, large versus small, or straight versus slanted—Sun Boxiang is able to energize his composition. The cursive rhythm of his work emerges in the geometric forms of the characters themselves, which range from triangular, square, and trapezoidal, to transformations based on these geometric forms.

Cursive script (*caoshu*) has gained increasing popularity because it is more immediately expressive than other types of calligraphy. In important exhibitions, cursive

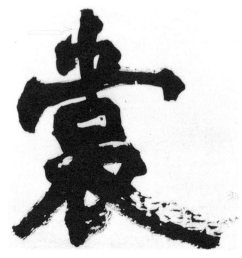

FIG. XIV

calligraphy currently constitutes a majority of submissions. Nevertheless, the spontaneity and apparent ease of cursive script, the source of its variety and flexibility, should not suggest that it is easy to create. Just as it has influenced other types of calligraphy, cursive script itself has also undergone considerable development in recent years. Analysis of recent cursive works will illustrate these changes.

Wild cursive is the most brilliant of Liu Zhengcheng's various styles (see CAT. 20). Not only is his cursive script the most famous among contemporary artists, it can also stand comparison with cursive works of the Ming Dynasty (1368–1644). Cursive calligraphy reached a peak during the Ming, and many contemporary calligraphers have found inspiration in works from this period.[12] Some calligraphers think of themselves as being in competition with their distant predecessors, pitting their own conceptions, skill, and technique against those of past masters. In this rivalry, however, contemporary artists by no means limit themselves simply to imitating ancient models but strive to develop their own personal techniques. Liu Zhengcheng's cursive script draws directly from the eighth-century calligrapher Zhang Xu and from Ming calligraphers such as Xu Wei (1521–1593). The speed with which Liu's brush moves and his unrestrained style are very much like Zhang Xu's wild cursive script (FIG. XV). But Liu's line is not the same as Zhang's, in which the tip of the brush generally is centered inside the line. Zhang re-

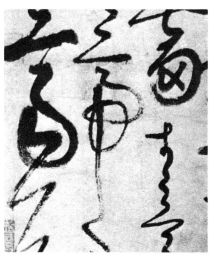

FIG. XV

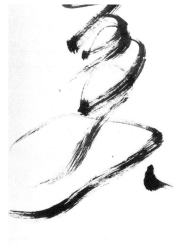

FIG. XVI

ferred to this type of brushwork as "hiding the point as if drawing in sand with an awl or pressing with a seal." Liu Zhengcheng's brushwork, on the other hand, is usually executed with the side of the brush, representing a

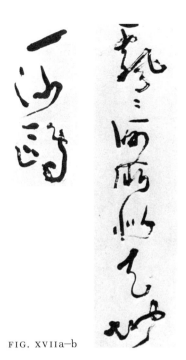

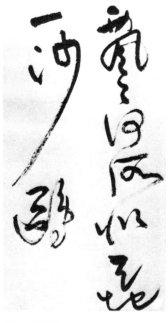

FIG. XVIIa–b

FIG. XVIII

fundamental departure from earlier wild cursive (FIG. XVI). In composition, Liu spaces the characters widely in order to give the surface more room to breathe and to create a contrast between space and line. Starting when the brush first touches paper, his rhythm gets faster and faster, and momentum gathers as the characters change from small to large, from restrained to free.

The cursive script of Shen Peng (FIG. XVIIa–b; see also CAT. 31–32) is derived from the late Ming style, especially the work of Wang Duo (1592–1652) (FIG. XVIII). Scholars and critics exalt Wang's calligraphy as "superhuman" (*shenbi*), and his work has strongly influenced modern Chinese and Japanese calligraphy. Wang Duo's special contribution was to achieve an overall balance by harmonizing the elements of calligraphy—brushwork, structure, composition, and so on—instead of emphasizing individual stokes.

Rather than imitate Wang's lines, Shen Peng adopted his idea of the comprehensive relationship of calligraphic elements. Shen's brushwork, for instance, conveys a sense of stability, firmness, and forcefulness similar to Wang's. He combines fast brushwork with heavy ink to produce a strong and solid effect. In writing an expanding line he gradually slows his brush, ending the stroke with a natural waviness that nevertheless appears stable, as in *di* (earth), the last character in the first column (FIG. XVIIa). Shen balances his strong brushwork by adopting exaggerated constructions of characters. In *piao* (draft) and *ou* (gull), one side of each character is conspicuously higher than the other (cf. FIGS. XIX–XXI). Many contemporary calligraphers enjoy making such precipitous constructions, a technique also derived from late Ming

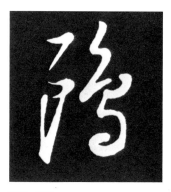

FIG. XIX FIG. XX FIG. XXI

calligraphers, but Shen counterbalances such structures with firm brushwork. In Shen's calligraphy, the opposing elements are organically integrated to give a sense of symmetry.

As for rhythm, Shen follows Wang Duo: the inclination of most characters is up toward the right and down toward the left. The first character, *piao*, shows this clearly (see FIG. XVIIa−b). The movement of the line surges upward from the lower left to the upper right, then falls suddenly, a cycle that repeats itself throughout the work. In this cadence, we recognize the fundamental key to this style of calligraphy. The character is constructed with a continuous line. In the next characters, a second *piao* and *he*, however, Shen changes his technique, writing them in a forceful pattern of broken and short strokes. The rhythm of the following characters, *suo* (so) and *si* (resemble), gradually slows down and the line becomes lighter. In the characters *tian* (heaven) and *di*, Shen speeds up again, creating a range of dark and light tones with a continuous stroke. This rhythmic variation establishes equilibrium over the whole composition. A difference between Shen and Wang is that Shen uses a brush made of long goat's hair, which produces thick strokes, while Wang used one of yellow weasel's hair, which produced thinner strokes. Despite this difference in line, Shen's ideas are clearly inspired by Wang. Both artists combine precipitous construction with firm brushwork, thereby endowing a dangerously steep style with stability. At the same time, their steady brushwork with both dry and moist ink demonstrates that there can be graceful elements to a strong and firm style. Consequently, their brushwork is integrated organically with the construction and application of ink, thus producing a balanced, elegant line.

The unification of the basic elements of calligraphy—brushwork, construction, application of ink, rhythm, and composition—is the means through which beauty is achieved. This can be seen in the works of contemporary calligraphers just as in ancient works. Modern artists view tradition as an attitude toward the relations between these elements rather than as a series of specific and historical calligraphic techniques.

What distinguishes one calligrapher's style from another's is often the emphasis on a single element within the consistent vocabulary of these five elements.

Wang Dongling, for instance, places the greatest emphasis on the application of ink (see CAT. 45). He prefers large images in ink that spreads out to permeate the texture of absorbent paper (FIG. XXII). The original path of the brush is only faintly visible, slightly darker than the ink that has seeped into the paper around it. Meanwhile, the spread of moist ink rounds out the outline of the character into a pleasing shape. The bold assertion of spreading shape, contrasting with the white paper, affirms the artist's confidence in the form-defining power of his brush. Usually, calligraphers create rhythmic effects through suspending lines (broken strokes) rather than continuing them. Wang Dongling, however, explores another way to create rhythm, namely, through the shape of the characters themselves, and especially the generous application of ink, which contrasts with his simplified and continuous lines.

Unlike Wang and many other calligraphers, Qi Gong, a professor and former president of the Chinese Calligraphers' Association, primarily explores the meaning of structure. In his view, Zhao Mengfu's (1254–1322) saying, "brushwork is the most important element, yet the artist must also carefully work on construction," should be reversed to favor construction over brushwork.[13] For Qi, the arrangement of the structure of each character is the foundation of the internal beauty of calligraphy. Qi takes a diagrammatic, analytical approach, seeking a system of proportional relationships that, interestingly, approximate the Western golden section ratio of 5:8 (FIG. XXIII). Although Qi's search for such proportional security is unique, his concern epitomizes his more general commitment to formal construction over brushwork.[14]

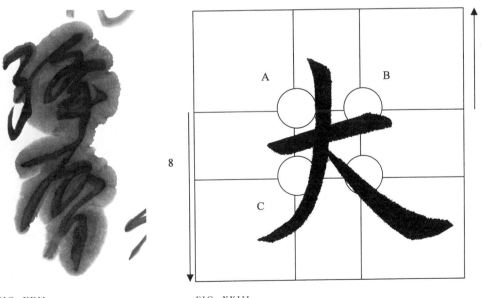

FIG. XXII (*cat. 45, detail*)

FIG. XXIII *Da, diagram of construction, by Qi Gong*

FIG. XXII

FIG. XXIII

Those who call themselves
modern calligraphers, such as
Shao Yan, Luo Qi, Bai Di, Zhang
Qiang, and Wang Dongling have
made a point of showing how
much they differ from other cal-
ligraphers, both predecessors and
contemporaries. Their motto is:
"We differentiate ourselves from
the ancients, from our contem-
poraries, and from each other."[15]

Liberalization in China
since 1976 has brought new pos-
sibilities in culture and the arts,
both through cultural exchange

FIG. XXIV

with foreign countries and from more subtle influences such as television. Literature,
fine arts, dance, and calligraphy have all been influenced by Western art, especially
contemporary work. Most of the modern Chinese calligraphers are young or middle-
aged artists who have been especially receptive to these new influences. When first ex-
hibited in Beijing in 1985, expressly modern calligraphy caused a stir in artistic cir-
cles. Twelve years later, the initial negative criticism by the government and by some
established calligraphers has abated. During the last year in particular, modern callig-
raphy has flourished as the number of exhibitions has increased. It is coming to be ac-
cepted as a legitimate form of expression by more and more people.

The remarkable differences between modern and traditional calligraphy can be
seen in the use of time, space, and technique. The order of characters when "writing"
calligraphy has been altered from the traditional pattern of top to bottom, and right to
left. The beginning and end of each brushstroke—which early in this century re-
quired special care to ensure that the shape was perfect—is more casual in modern
calligraphy, and strokes may or may not follow the traditional sequence. In *Splendor of
the Past* by Zhang Dawo (FIG. XXIV), for instance, the line is twisted in several curves
to the point that the viewer loses all sense of sequence and cannot be sure of begin-
ning or end.

An even more vivid distinction between modern and classical calligraphy is in
the use of space. In a work of modern calligraphy, a radically varied sense of space
augments the composition. A new theory of composition has emerged. As the modern

calligrapher Yang Zhaoling has noted: "The first requirement for people who are engaged in modern calligraphy is to change the composition and construction of each character, which leads to new uses of space."[16]

It follows that the spacing of characters will be different—more experimental and deliberately inventive—from that of classical calligraphy. Su Yuanzhang's *Through the Yangtze Gorge* (*Zaofa Baidi Cheng*) (FIG. XXV), for instance, uses calligraphic forms to mimic the forms of landscape painting. The name of the work comes from the final two lines of a famous poem by Li Bai (A.D. 701–762), whose characters make up the landscape:

> *While monkeys vainly hail me from both banks,*
> *My boat has already sped ten thousand mountains away.*[17]

FIG. XXV

FIG. XXV *Su Yuanzhang, Through the Yangtze Gorge (1985)*

The characters for the river banks, the monkeys, and their calling are aligned along an incline and are drawn unevenly, as if they really are on the far bank of a river. The small characters appear suspended in the distance, mimicking a location deep in far mountains. The three characters of "ten thousand mountains" (*wan chong shan*) stand firm and upright in the foreground, as if on the near bank. The other three characters, *zhou yi guo* (my boat has already sped), are written much smaller and placed between the two river banks, like boats flowing quickly and unimpeded on the Yangtze River. Thus, the image, essentially pictorial in structure, is organically united with that of the poem.

This new idea of composition is an important breakthrough. Lu Chen, like most modern calligraphers, believes that "in the past, calligraphy focused only on the relationship between adjacent characters, the connection of the last stroke of one character to the first line of the following character. Beauty was attained by changing the brushwork. In contrast, modern calligraphy is more concerned with the construction, the structure of calligraphy itself, and the composition of the entire work."[18] This critique of composition in traditional calligraphy represents an innovative approach. The Yuan Dynasty calligrapher Zhao Mengfu emphasized brushwork as "the most

important element in calligraphy" (*yongbi weishang*).[19] He believed that although the construction of each character changed over time, the brushwork never did. He considered the spatial elements to be of secondary importance. Modern Chinese calligraphers, however, are more interested in spatial composition and emphasize a pictorial or architectural use of space.

Traditional conceptions of composition lie at the heart of modern calligraphy. In the Eastern Jin Dynasty (A.D. 317–420), the earliest known definition of composition was proposed by Wang Xizhi: "Before one can create calligraphy, one should plan many kinds of contrasts, such as large and small, straight and curved, inclined and upright. At the same time, one must make the contrasts show internal connection. . . . If calligraphic characters look like the beads on an abacus, that is, the upper and lower parts are even, they do not represent variation, and they cannot be considered art."[20] Wang held that such variation should demonstrate contrast, symmetry, and harmony. He also proposed some concrete principles for creating good calligraphy, usually presenting them in contrasting pairs. Those with particular relevance to composition include: a strong brush requires soft paper, and a soft brush requires strong paper; a heavy line should not be too long, and a simple structure should not be too large.[21]

While Wang's writings represent the beginnings of a theory of composition, in the works of Huang Tingjian (1045–1105) composition ceases to be a secondary consideration and assumes a more central role. Consciously seeking and achieving equilibrium in his work, Huang Tingjian emphasizes contrast and balance between contiguous columns of characters, as opposed to individual characters. This effect is achieved by contrasting large characters with small, inclined characters with upright ones, straight lines with curving lines, and heavy strokes with light, maintaining each of these contrasting elements over entire sections of a composition (FIG. XXVI). Huang Tingjian believed that a work of calligraphy should be evaluated not on the basis of particular parts or strokes but rather on the basis of the entire composition.

With the exception of some remarkable figures such as Wang Xizhi or Huang Tingjian, however, most calligraphers of the past focused on the structure of the

FIG. XXVI *Huang Tingjian, Zhushangzuo (detail)*

FIG. XXVI

individual character. Recently, but especially over the last decade or so, as the practice of calligraphy has changed, composition is becoming the central focus. A good example of the current focus on composition is Wang Yong's *Sea Is the Dragon's World* (CAT. 48). All five characters have rough outlines that appear as variations on geometric forms; all of them tilt from upper left to lower right, in a dynamic diagonal movement. The left and right sides of the trapezoidal character *long* (dragon), the largest of the five, overlap with the two bordering characters. These three intertwined figures are closely fused, and their collective weight and energies assert an imposing pressure on the two smaller characters below. Through the techniques of overlap, linked shapes, and uniform diagonal movement, and through the exclusive use of solid rough strokes, Wang Yong weaves the five individual characters into a single integral unit. This goes a step beyond Huang Tingjian's approach of balancing groups of characters, in which the sense of equilibrium and symmetry is achieved by juxtaposing a few essentially separable elements. In Wang Yong's work, no part of the composition can be considered separately from the rest, and the overall impression of overwhelming force and activity is conveyed by the shifting mass of the composition as a whole. No single element can be shifted or dropped, any more than a single dot or stroke could be eliminated from one of the characters in Wang Xizhi's calligraphy.

Contemporary calligraphy often combines several types of script in one work: standard, running, cursive, and clerical. Also, it uses many artistic methods, borrowed variously from classical Chinese calligraphy and painting, and even from modern Western art. Of all the borrowed elements, painting—both Chinese and Western—is the leading source of inspiration.

The idea that painting and calligraphy derived from the same source was first articulated during the ninth century by Zhang Yanyuan in his *Lidai Minghua Ji* (Record of Famous Paintings Throughout History).[22] In the Yuan period (1272–1368), Zhao Mengfu offered several specific ideas concerning calligraphic brushwork in his own painting. He adopted the "flying white" brushwork to the texture of rock and used seal script techniques in the execution of the trunks and branches of trees. He drew bamboo leaves with the classic vocabulary of calligraphic strokes known as the "eight methods of the character *yong*," highlighted to express the beauty and rhythm of calligraphic line in painting (FIG. XXVII). The Qing calligrapher Zheng Banqiao (1693–1765) worked in the other direction, appropriating the willow leaf stroke from Chinese painting to write calligraphy.

Every artist believes that he has his own individual way to combine painting and calligraphy. Works of contemporary artists—such as He Yinghui, Liu Zhengcheng, Wang Yong, Wang Xuezhong, and Zhang Daoxing in this exhibition—all reveal their own calligraphic lines in their painting. Wang Yong's *Landscape* (CAT. 50), for

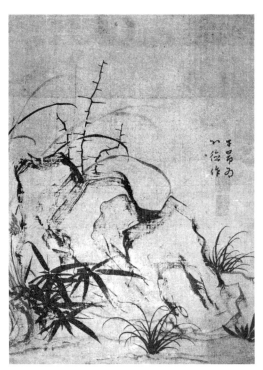

FIG. XXVII

FIG. XXVII *Zhao Mengfu, Rock and Bamboo (ca. 1310)*

instance, is constructed of very free brush movements. In particular, he likes to apply the rough strokes of his cursive style to the entire composition. He draws the bank of a brook, the trunk of a pine tree, or the edge of a hill with extended elastic curves, which are further interlaced or matched with throbbing dots. These curves and lines are less a representation of nature than a conscious or unconscious conversion of calligraphic brushwork. The incorporation of calligraphic brushwork into painting provides a new freedom and energy, conveying a sense of even greater mobility to the image.

Similarly, Zhang Daoxing's figure painting is not a simple realistic reproduction of actual scenery. Rather, his technique is mainly square brushwork, influenced by his study of Northern Wei stelae, in which turns are angular, not curved. The characters *dao xing xie* in *Weighing Fish* (CAT. 57) are inscribed by Zhang himself. Even though written in cursive style, the brushwork appears square-shaped, with sharp turns, many short lines, and long straight lines. The lines on the back of the mother's sling are rendered with brushwork similar to that in the inscription, revealing some of the distinct characteristics of his calligraphy, especially with its dry ink applied with the side of the brush, clearly displaying "flying white."

The importance of the marriage of painting and calligraphy in Zhang's painting is most apparent in his use of calligraphic space. *Daily* (CAT. 56) offers a good example: the composition balances areas of dense ink and sparse ink, and the light traces of dry brushwork surrounded by the dark patches of thick ink create a sense of harmonious space. The same technique can be seen in his *Weighing Fish*: instead of light and dark areas, Zhang has distributed areas of blue, yellow, and green to create a sense of space and balance.

The union of painting and calligraphy is an especially rich phenomenon, opening a range of expressive possibilities, which have been insistently explored in modern calligraphy. In contrast with traditional art, modern calligraphy incorporates more diverse elements and applies them more self-consciously, especially those methods derived from painting. Many modern calligraphers enjoy "painting" ancient pictographs.

One example is *Moon and Boat* by Xu Futong (FIG. XXVIII). The image is derived from the name of an ancient seal cutter, which consisted of the two characters "moon" and "boat." The "moon" hangs in the dark sky surrounded by many flashing stars while the ancient "boat" seems to flow on a river or in the Milky Way. This is a seamless and very innovative fusion of painting and calligraphy.

The use of pictorial techniques was quite popular in the mid-1980s, as in Su Yuanzhang's *Through the Yangtze Gorge* (FIG. XXV), discussed above. More recently, many modern calligraphers recognize that the technique of paintinglike calligraphy has had both positive and negative aspects and are experimenting with other approaches. On the positive side, paintinglike calligraphy is easier to read and more accessible. On the negative side, however, questions have been raised as to whether representation is appropriate as the main element of calligraphy: Is it a representational art or an expressive art? Some scholars argue that representational images betray a misunderstanding of the essential qualities of Chinese calligraphy.[23] Many calligraphers and scholars believe that calligraphy is more expressive than representational. Although early pictographic forms of calligraphy had some representational characteristics, calligraphy's beauty does not derive from them. In other words, the beauty of Chinese characters, even the purely pictographic ones, can be attributed to formal principles of line and construction. According to these calligraphers and scholars, representational characteristics cannot substitute for the beauty of brushstrokes.

This debate has encouraged some calligraphers to explore new directions, some of which involve structural and symbolic methods. Shao Yan, in *Surrounding* (CAT. 28), for instance, takes great pains to make the structure of his single-character work embody the character's meaning. The opposite boundaries are parallel; the top and bottom lines merge with the edges of the field, while the right and left lines incline from the upper left to the lower right. In these four boundary lines, the outer edges are sharp, cut by the limits of the paper, while the inside edges are uneven, with white space in the lines. These lines are not true calligraphic lines; rather, they are inspired by the West, by Abstract Expressionist

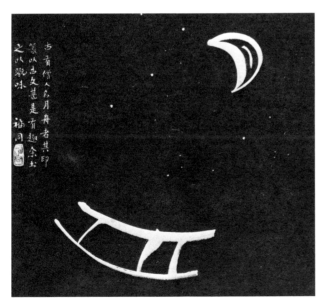

FIG. XXVIII

FIG. XXVIII *Xu Futong, Moon and Boat (1985)*

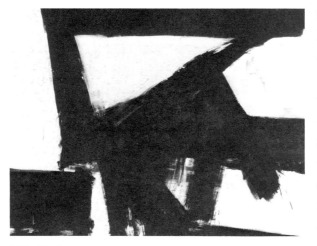

FIG. XXIX

models (i.e. FIG. XXIX). The two horizontal lines at the upper part of *Surrounding* are executed with "flying white" while the other two horizontal lines spread into one heavy line of moist ink. The movement of the four lines tends to the right side. In the vertical strokes on the top, one dominates in the middle and parallels the other two lines on either side, while another is in the opposite position on the right side. The vertical line on the lower part of the character has been moved from the center to the left side. The *kou* in the middle of this character is a trapezoid, which balances the outline of the whole character. The outline of this work suggests the wall of an ancient city or family compound, with internal activity, people trying to escape their surroundings. The "surrounding" is so solid that no one can get out.[24]

In Shao Yan's *Nonbeing (wu)* (CAT. 29), the meaning is implied by the structure of the character. Two horizontal strokes incline from the upper left to the lower right, while the third line moves from the lower left to the upper right. This third line seems to overlap with the second horizontal stroke, but it does not. The fourth horizontal line, at the bottom, is flat yet seems to contain space, owing to the contrast of dark edge and lighter interior created by a wash technique. Of the three vertical lines, the two outer ones are parallel, while the middle one is inclined; together, they support the heavy structure of the top of the character. The strokes on the bottom of the structure have a large space between them, which seems to symbolize nonbeing. Lao Zi (ca. 571–471 B.C.) believed that "being (existence) derives from nonbeing (nonexistence)." In Daoist thought, nonbeing is the more truthful of the complementary pair because space is the basis of life, the root, without which nothing on the earth would grow.[25] The arrangement of *wu* hints at this ancient philosophy: nonbeing is essential, at the base of everything.

Some modern calligraphers seek powerful abstract forms so consciously that they try to deny the meaning of characters. This noncharacter calligraphy has been called postmodern calligraphy or calligraphyism.[26] The practicioners of calligraphyism are, in turn, divided into two groups. One, while not denying the Chinese calligraphic line, avoids using characters: Bai Di's work is a good example (see CAT. 4). He uses typical cursive script brushwork, yet the result cannot be read even though the lines and radicals he forms are parts of Chinese characters.

Another type of noncharacter calligraphy is executed through essentially noncalligraphic lines and structures. In Liu Tianyu's *Fission of Point* (FIG. XXX), for instance, the center is dense and the outside dispersed, an image evoking the big-bang theory of the origin of the universe. Like a detonated atomic bomb, the point spreads from the center with incredible force and speed. This dot shape cannot be found in traditional calligraphy. Parting from most modern calligraphers who still pursue a pictorial representa-

FIG. XXX

FIG. XXX *Liu Tianyu, Fission of Point (1992)*

tion of individual characters, and also from traditional calligraphers who adhere to traditional brush methods, Luo Qi develops his theories of calligraphyism by pushing beyond the limits of the art (see CAT. 24). Abandoning established ink, brush, and stroke order, Luo effectively inaugurates a new era, a departure from the nationalistic aspects of traditional art to embrace pure expression.

Abandoning the use of characters raises an important question concerning not only the practice but the essence of calligraphy. Calligraphy is an independent genre of art that combines certain general and specific characteristics. General characteristics include the manifestation of lines—continuous and broken, fast and slow, heavy and light—similar to the rhythm of music, the movement of dancing, and the structure of architecture. The particular characteristics involve characters, which introduce a textual dimension of meaning and thought, making calligraphy different from other visual arts. Although the aesthetic effect of a work of calligraphy is not determined by the meaning of the characters, excellent work always unites the forms of the characters with their meanings. The main distinguishing factor of calligraphy is its origin in text. Because of this, calligraphy can express feelings more directly and with more precision than other visual arts.

Although modern calligraphers seek to transcend certain limitations of traditional calligraphy, they are necessarily concerned with the meaning of characters. The question of whether or not characters form the basis of modern calligraphy has produced some controversy. On the one hand, if it emphasized the meaning of characters, modern calligraphy would restrict itself to being verbally determined, unable to claim aesthetic status as its own art. On the other hand, without the distinctiveness of the character's form, modern calligraphy would be no different from Western abstract art,

similarly surrendering its claims to aesthetic independence as an art. The problem is a major concern of modern calligraphers. Lang Shaojun is among the theorists who suggests setting limits for postmodern calligraphy: "If we use the concept of modern art to guide modern calligraphy, it will bring about abstract painting. No matter how good it is, it will not be calligraphy. How to resolve this problem? I hold that we should set a limitation between abstract painting and modern calligraphy. . . . In any case, calligraphy cannot merge into abstract painting. Calligraphy has a basic condition of existence, which is that it is based on characters. No matter how powerful of expression or creation, the delineation of space for modern calligraphy is very narrow. It should not cross the boundaries into ancient calligraphy or modern painting."[27]

Nevertheless, modern calligraphy does not stand in opposition to traditional calligraphy. The essence of modern calligraphy lies in its variability, while traditional calligraphy represents simplicity. The art of calligraphy is based on the principles of harmony and opposition; traditional calligraphy emphasizes harmony while modern calligraphy stresses difference. Modern calligraphy tries to fuse many diverse methods, types, and styles of art, thereby breaking with historical practice. Traditionally, a calligrapher might practice many different types of calligraphy but would probably not be well versed in every one. Modern calligraphy tries to combine different types of calligraphy, to accommodate variety within a unified system, thus rendering calligraphy even more complex. The uneven quality of works produced in the pioneering early period of modern calligraphy attests to the difficulty of the challenge.

The essence of historical calligraphy lies in its simplicity of form, which is not the same as simplicity in meaning, as some have proposed. On the contrary, the meaning of historical calligraphy is exceedingly rich. The attempt to represent unity through variety and the attempt to represent variety through unity are different but not opposite approaches. Seeking greater variation of artistic form, modern calligraphy encourages greater expressive freedom, thereby affording more direct artistic accessibility. The meanings present in historical calligraphy cannot be understood immediately; they must be savored over a long period of time. To quote Lang Shaojun once more, "Calligraphy is a very common form of art but one that is also very difficult to understand."[28] Modern calligraphy, however, can be appreciated quickly, since it emphasizes the spatial elements and appeals directly to our eyes. At the same time, most modern calligraphy continues to unite the content of words with artistic form. The style of calligraphic lines and dots matches the style of the characters.

A remarkable feature of modern calligraphy is its casual choice of words, which may include satirical or humorous phrases instead of a serious saying or poem. In this way, modern calligraphy reflects modern life and culture. Zhang Hongyuan's *Go with Your Feelings* (FIG. XXXI) is a good example of this tendency. "Go with Your Feelings"

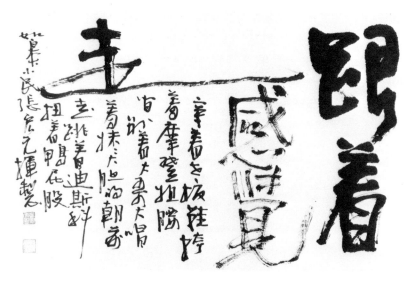

FIG. XXXI

FIG. XXXI *Zhang Hongyuan, Go with Your Feelings (1994)*

is the title of a song, popular during the initial years of reform (ca. 1985), which speaks of following one's feelings and letting them lead wherever they might go. The Chinese government often declared that no one could know the exact direction of reform, that it was like crossing a river by feeling for the stones. "Go with Your Feelings" was timely, the lyrics paralleling official policy statements. Although the composer may not have intended to satirize the government, the song offers an honest reflection of popular life and psychology. Zhang does not completely follow the text of the song. Instead he injects new slang and, after five characters, invents his own text:

> *Wearing the boss's shoes,*
> *Fondling modern girls.*
> *Hanging a mobile phone from my waist,*
> *Singing "Sister Goes Forward Bravely."*[29]
> *Dancing disco,*
> *Wiggling my butt like a duck.*

The form of the calligraphy follows the injunction to "go with your feelings." The characters for "go with" are executed with very heavy ink, which emphasizes the commanding action in the title. "Feelings" is drawn in dry ink with "flying white," which contrasts with the dark "go with." The last character in the third column dominates one and one-half columns and exaggerates the last stroke on the top of "feelings," which not only balances the arrangement but also makes the image of *Go with Your Feelings* even brighter.

In the connection that it creates between brushwork and spatial relationships, then, modern calligraphy stresses composition over brushwork, marking a new direction in the practice of calligraphy. In technique, modern calligraphy simultaneously

applies a greater number of elements and variety of styles than traditional calligraphy. Adopting elements of painting and architecture, modern calligraphers emphasize spatial qualities, which not only changes the sequence of execution but also adds a new dimension. In addition, most modern calligraphy maintains a fundamental principle: verbal style (the meaning of characters) parallels calligraphic style (the meaning of line), which is more readily perceived and easier to understand than in the case of traditional calligraphy. Modern calligraphy belongs to modern life and a modern appreciation of art. Just as it has broken with basic assumptions and practices of traditional calligraphy, so the proper criticism of this art must find new ways to transcend traditional standards of evaluation. It requires a modern critical approach—a critical vocabulary and analytical methods adequate to its own modernity. The proper criticism of modern calligraphy must develop along with its subject.

NOTES

1. See "Saikele Bei Shufa Jingsai Jianjie," *Zhongguo Shufa* (1991, no. 2):43.

2. One yuan is worth approximately $0.12. In 1997 at the Seventh National Exhibition of Middle-Aged and Young Calligraphers, each of ten first-prize winners was awarded 20,000 yuan (approximately $2,400).

3. For further information, see the interview with Liu Yi, "Jiakuai Gaige Fanrong Chuangzuo: Liu Yi Tongzhi Jiu Diwujie Quanguo Shufa Zhanlan Da Benkan Jizhe Wen," *Shufa* (1992, no. 5):4–6.

4. See "Pengbo Fazhan De Shufa Shinian," *Zhongguo Shufa* (1991, no. 3):2–4.

5. For a discussion of the coal mining club, see Zhou Junjie, "Dihuo Zhu Zhenhun: Ji Quanguo Meikuang Shufa Yanjiuhui Jiqi Huizhang Liang Dong," *Zhongguo Shufa* (1991, no. 4):49–58.

6. *Zhongguo Shuhua Bao* (17 August 1995) devoted an issue to calligraphy education.

7. Few were by well-known calligraphers. Zhao Zhiqian's couplet went for 100,000 yuan. For further information on this sale, see "Jiade 95 Nian Chunji Paimaihui Zai Jing Juxing," in *Zhongguo Shuhua Bao* (1 June 1995).

8. For a basic study of brushwork, see Shen Yinmo, "Shufa Lun" (On Calligraphy), in *Xiandai Shufa Lunwen Xuan* (Selected Essays on Modern Calligraphy) (Shanghai, 1980) 1–26; for a study of brushwork, construction, and composition, see Zong Baihua, "Zhongguo Shufa Li De Meixue Sixiang" (Aesthetics of Calligraphy), in *Xiandai Shufa Lunwen Xuan*, 96–117. For further discussion of the five elements and their relationship, see my book *Shufa: Xinling De Yishu* (Calligraphy: The Art of Heart and Soul) (Beijing, 1991) 39–52.

9. "Flying white" is a special effect produced by applying a relatively dry brush at high speed. The brush applies ink unevenly to the paper, producing strokes that are a combination of thin lines of ink and dry white streaks. These white streaks, which convey a sense of lightness and speed, are the origin of the term "flying white."

10. For a study of Wang Youyi's calligraphy, see Zou Tao, "Gui Zai Shenzao Qiu Qi Tong: Qiantan Wang Youyi Shufa De Tansuo," *Zhongguo Shufa* (1991, no. 3):48–49.

11. Some scholars and artists have criticized Li Ruiqing's artificial shaking. See my discussion, "Li Ruiqing Kaishu," in *Zhongguo Shuhua Jianshang Cidian* (Beijing, 1988) 1501.

12. Tang Dynasty calligraphers created a style called wild cursive. In the Ming period, cursive script and wild cursive script were developed further, bringing the cursive style to its historical zenith.

13. Qi Gong, "Lun Bishun, Jiezi, Ji Suotan Wuze," *Shupu* (1987, no. 5):24–33.

14. Ibid., 26–29.

15. Gu Gan, "Xiandan Shufa Sanbu," *Xiandai Shufa* (1994, no. 5):17.

16. Yang Zhaoling, "Xiandai Shufa De Jueqi Jiqi Fazhan," *Xiandai Shufa* (1994, no. 3):27.

17. Translated by Zhang Yiguo and Harry Miller.

18. Lu Chen, "'Shao Yan Shufa Zhuangzuo Zuotanhui Fayan Xuandeng," *Zhongguo Shufa* (1993, no. 3):49.

19. An Qi, *Mo Yuan Hui Guan Lu* (Comprehensive Record of Ink Acquaintances: A Catalogue of An Qi's Collection of Calligraphy and Painting), *Guoxue Jiben Congshu*, vol. 155, *juan 2* (Taibei, 1986) 111–13.

20. Wang Xizhi, "Ti Wei Furen Bizhentu," in *Lidai Shufa Lunwen Xuan*, vol. 1 (Shanghai, 1980) 26–27.

21. Ibid., "Shulun," 29.

22. Zhang Yanyuan. *Lidai Minghua Ji* (Beijing, 1985) 7–12.

23. Li Xianting believes that *Through the Yangtze Gorge* is an example of such misunderstanding. For this issue, see his "Xiandai Shufa Zhiyi: Cong 'Shuhua Tongyuan' Dao 'Shuhua Guiyi,'" *Shufa Yanjiu* 46 (1991, no. 4):25.

24. See Li Shilao, "'Shao Yan Shufa Zhuangzuo Zuotanhui Fayan Xuandeng," *Zhongguo Shufa* (1993, no. 3):4

25. See Patrick E. Moran, *Three Smaller Wisdom Books* (*Lao Zi's* Dao De Jing, *the* Great Learning [*Da Xue*], *and* Doctrine of the Mean [*Zhong Yong*]) (Lanham, Md., 1993) 87.

26. Luo Qi edited a collection of essays about calligraphyism in which Zhu Peier wrote an excellent paper dealing with the relations between calligraphyism and both traditional calligraphy and modern calligraphy. See his "Tan 'Shufa Zhuyi' Chansheng De Yiyi Ji Qita," *Shufa Zhuyin Wenben: 1993–1996* (Guangxi, 1997) 150–73. See also Lang Shaojun, "Hou Xiandai Yuanze: Yetan Xiandai Shufa," *Shufa Yanjiu* 46 (1991, no. 4):11–17.

27. Lang Shaojun, "Shao Yan Shufa Chuangzuo Zuotanhui Fayan Xuandeng," *Zhongguo Shufa* (1993, no. 3):50. See also his "Hou Xiandai Yuanze: Yetan Xiandai Shufa," 11–17.

28. Lang Shaojun, "Hou Xiandai Yuanze: Yetan Xiandai Shufa," 11.

29. This is the title of a famous song from Zhang Yimou's film *Red Sorghum*.

CATALOGUE OF WORKS IN THE EXHIBITION

FIG. 1A *Qing, by
Ni Yuanlu, from a
hanging scroll*

FIG. 1B *La
(detail, cat. 1)*

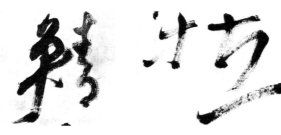

FIG. 1A FIG. 1B

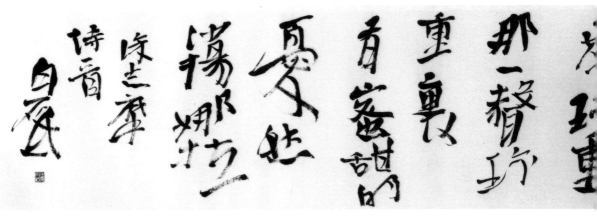

CAT. I

CATALOGUE OF THE EXHIBITION

All works belong to the artists. Dimensions are in centimeters, height before width, and do not include mounts.

BAI DI

Bai Di, born in Shaoxing, Zhejiang Province, in 1965, is the youngest calligrapher in the exhibition. As a student at the Chinese Academy of Fine Arts in Hangzhou, he will be the first ever to have received a Ph.D. in calligraphic studies. A calligrapher of the new generation, he has received many awards, including prizes at the Sixth (1995) and the Seventh (1997) Young and Middle-Aged Calligraphers' Exhibitions.

1. SAYONARA, 1994

Ink on paper (running script), 37.3 x 239.5 cm.
Seal: "Bai Di, from Shanyin"

> *She is gentlest when her head bows,*
> *Resembling the lotus flower.*
> *Too timid to bear the cool breeze,*
> *Saying, "take care,*
> *Take care."*
> *In her "take care," there is the sadness of sweet honey.*
> *Sayonara.*
> *— Poem by Xu Zhimo [1896–1931]*

Bai Di's work falls into three categories: traditional, in which he addresses ancient calligraphic forms, using rubbings of stone inscriptions; personalized traditional, works in a personal style but still related to traditional calligraphy; and modern, in which he connects traditional methods with contemporary ideas of color. His works in this exhibition are of the second or third type.

In Bai Di's personalized traditional style, this work reflects his emergence from traditional calligraphy. The square brushwork, steady writing, and condensed lines are inherited and developed from the style of Ni Yuanlu (1593–1644) (FIG. 1A), but Bai's structure is quite different. In Ni's calligraphy, most characters are high on the right, low on the left, with right-closure and left-release, the lines of each character continuous. Bai's scripts are variable: in *la* (FIG. 1B), for instance, he freely combines right low and left high, left small and right large, left-closure and right-release. Not all the characters spread from the upper left to upper right; rather many extend to the lower right. In these characters, right and left forces create an asymmetrical balance. In addition, the thickness of the line varies, nor are all the strokes connected. This results in what is traditionally called "broken strokes with connected meaning" (*biduan yilian*).

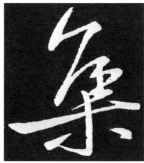

FIG. 2A

FIG. 2A *Ji, by Wang Xianzhi, from Chunhuage Tie*

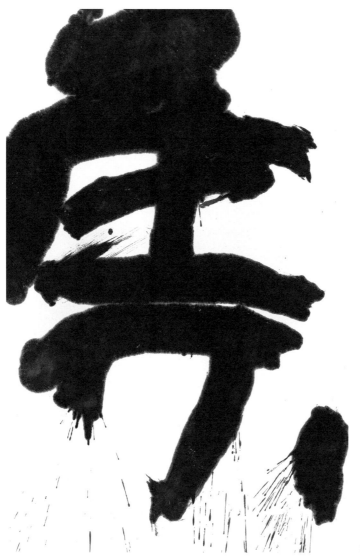

CAT. 2

2. SOLIDIFYING SPACE AND TIME, 1991

Ink on paper, 96.5 x 64.0 cm.

Bai Di's modern calligraphy boldly explores the creation of composition in novel patterns. In the single character *ji* (assembling), the initial or uppermost leftward down-stroke is short but strong in pressure, a distinct departure from Wang Xianzhi's (A.D. 344–386) treatment (FIG. 2A). The second horizontal is thinner, with a slight arc. The third horizontal line links with the vertical at the left, breaks up the central vertical line, and overlaps the upper horizontal line. This bold gesture concludes with a quick lift of the brush, a "flying white," which connects with the third and fourth horizontal lines directly beneath. The last horizontal line is an arc whose midpart clings to the upper line. The third vertical stroke, at the lower right, inclines to the left, boldly dividing the two dots now around it. The ending hook stroke echoes the radiating left dot.

Ink on paper, 128.6 x 64.5 cm.

Strength and Speed is a combination of cursive structure with seal script construction of the character for "complexity," *za* (cf. FIG. 3A). The initial stroke on the upper left is swift and powerful: the flying ink splashes toward the upper and lower right, with the cut left edge implying a continuation and growth into the outlying space. The chain arcs on the left and the lower right are typical seal script, and the joining parts are bound together in a solid link. The final stroke, at the bottom, drawn from upper left to lower right, emphasizes the diagonal movement, even as it suggests a foundational closure.

Initially, this work may recall the abstract art of an American painter like Robert Motherwell as well as modern

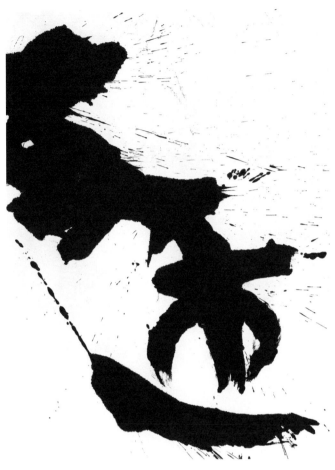

CAT. 3

Japanese calligraphy. But Bai Di's originality should be gauged against Chinese calligraphic tradition, in his respect for the temporal aspects of writing: the sequence of strokes is central. While keeping the writing in proper traditional order, Bai stresses rhythm and density in his line. This distinguishes him from the Japanese avant-garde. Unlike other Chinese modern calligraphers, he pursues neither thickness of line nor variety of ink nor pictorial expression. Instead, he creates an organic unity of time, space, and rhythm.

FIG. 3A

As a bold leader of avant-garde Chinese art, Bai Di believes that his own art works and his research in traditional calligraphy share a common source. These "fewer-character" works (*shaoshu zi*) contain anywhere from one to three characters (occasionally more) and are distinct from those containing more text. *Shaoshu zi* maintain traditional traits such as line quality, rhythm, and structure and simultaneously emphasize the contrast between black and blank spaces, the mutual contrast of yin and yang.[1]

FIG. 3A *Za, by Wang Xizhi, from Chunhuage Tie*

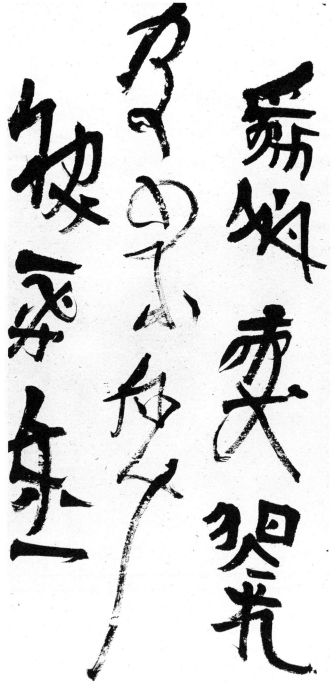

CAT. 4

4. NONCHARACTER CALLIGRAPHY, 1997

Ink on tan paper, 137.7 x 67.1 cm.

In *Noncharacter Calligraphy* the composition and modulation of lines are based on traditional methods. Although the lines are typically calligraphic, the "characters" themselves cannot be read as linguistic entities. These illegible lines demonstrate that the beauty of calligraphy can reside within the abstract patterns and rhythms invented by the artist, in the balance within the strokes, characters, and columns. Bai Di's modern works pay tribute to a tradition that they extend and critique, expressing "extremely conventional connotation with extremely modern form," as the artist himself has written.[2]

Han Tianheng was born in Shanghai in 1940. Vice president of the Shanghai Research Institute of Chinese Painting, he is an expert calligrapher, seal cutter, and painter, whose works have been acquired by institutions around the world, including the British Museum. Han Tianheng calls his residence "The Studio of Extreme Happiness."

5. SEALS, 1997

Ink and red color on paper, 68.2 x 95.2 cm.

> "The Slave of Color," "Yao Quan" (5.1), "Gaifu," "Self Control," "The Studio of Yu Wenshan"; "The Year of Dingchou," "All Goes Well," "The Studio of the Powerful Sunset," "Tasting Leisure" (5.2), "The Seal of Piao Longxiao," "Tasting Leisure"; Dragon (image), "Tasting Leisure," Buddha (image), "The Hand Does Not Follow the Heart," "Southern Dragon"; "Guiyan," "Master of the Literary World and Infinitely Honorable," "As Stubborn as the Ox," Dragon (image), "Chunyang," "Lingxian"; "Ten Thousand Years" (5.3), "Tasting Leisure," "Long Life" (5.4), "The Seal of Fang Zengxian"; "The Studio of Extreme Happiness" (5.5)

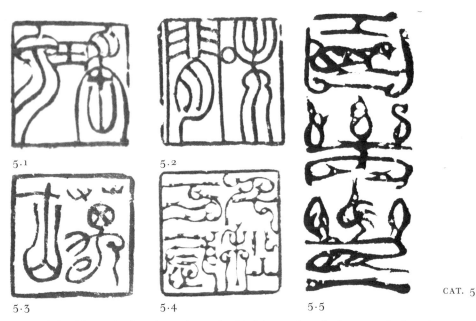

5.1 5.2

5.3 5.4 5.5 CAT. 5

Among Han's highly praised seal carvings, the bird-insect inscriptions are the best known. This form of seal inscription was first popular in the Qin (221–206 B.C.) and Han (206 B.C.–A.D. 226) Dynasties (FIG. 5A). It displays not only abstract lines but pictorial images as well, giving writing a somewhat ornamental flavor. Since Chinese calligraphers and seal carvers have generally preferred more abstract, schematized forms of script, the study of bird-insect inscriptions has been neglected for a long time.

 Han Tianheng, however, has his own ideas on this subject. The intertwining thick and thin lines, both straight and curved, round and square, display extraordinary creativity. The result is dancing, flowing, fresh, and animated. Drawing figures of birds and insects with vivid

FIG. 5A *Bird-
insect inscription,
Qin or Han Dy-
nasty*

FIG. 5B *Zhai, by
Xu Shen (d. 120),
from Shuowen*

abstract lines, Han emphasizes a kind of
pictorial delight and ornamentation. His
achievement lies in coherently combining
the characteristics of painting and writing;
there is a naturalistic delight within this
constructed form.3

FIG. 5A FIG. 5B

"The Studio of Extreme Happiness"
(CAT. 5.5) is representative of Han's work.
There is a tiger in *bai* (extreme or hun-
dred), a snake and a deer in *le* (happiness), and a red-crowned crane and rooster in *zhai* (stu-
dio) (cf. FIG. 5B). They are all auspicious animals with symbolic meanings: the tiger and
dragon stand for power and strength, the rooster symbolizes honor and fame, and the crane
and deer represent longevity. The animal figures not only provide decorative dots and lines
but graphically contribute to the overall formal beauty as well. These forms present an obvi-
ous contrast between the blank and the line, what is often referred to as negative and positive
space. The mid-horizontal line of *bai* is not linked with the lines on either side, resulting in a
tension between balance and unbalance. Balance is achieved in the more or less symmetrical
positioning of these marks, while their separation from what is below simultaneously allows
those same marks to float. Two groups of twisted strokes on either side of *le* spread left and
right, while the other two groups in the bottom character tend toward closure. The solid,
squared knife-work carves short, curving strokes, which flow from side to side, up and down,
and connect each other, paradoxically creating a relatively axial movement.

6. BA WOMAN, 1997

Ink on paper (seal script), 153.0 x 84.0 cm.
Seals: "Painting from Heart," "Precipitous," "Han," "Tianheng," Dragon (image), "Peace
and Health," "Auspicious," "The Studio of Doulu," "The Studio of Extreme Happiness," "Ex-
treme Happiness," "Tasting Leisure," and "Controlling Space and Understanding Line"

> *The Ba water is fast as an arrow,*
> *The Ba boat travels as if flying.*
> *Ten months and three thousand miles,*
> *When will my husband return from his journey?*
> —Li Bai (A.D. 701–762)

Cursive and seal characters differ in that their construction and brushwork belong to different
systems. In cursive, the lines are smooth, the brush is fully used, and the characters are written
quickly with a strong rhythm. In seal characters, however, the lines are solid. The center of
the brush always goes in the middle of the line. Seal script is written slowly, with little em-
phasis on rhythm or variety in the thickness of strokes. By combining the two different kinds
of calligraphy, Han created a new style, which he called "cursive seal." In this new script,
Han's characters appear as irregular symbols full of rhythm. The lines have edges and corners,
and the slow but firm strokes seem to move up and down; those written with the center of the

brush are jagged, as if carved by a knife. His process can be illustrated by comparing his seal carving and his calligraphy: His seal *"Zhi bai shou hei"* (Controlling Space and Understanding Line) (FIG. 6A) displays his knifelike brushwork clearly. Then, in *gui* (return) (FIG. 6B), he draws curves whose edges and corners closely resemble the marks in the upper right corner of the seal. In both the seal and its calligraphic transposition, similar shapes and movements are preserved. The lines normally produced in seals with a slanted knife are imitated calligraphically, using a brush rather than a knife. Making effective use of the difference between the speed of knife and brush, Han produces a dry "flying white" that is different from regular cursive. Though "flying white," these lines nonetheless remain carved and powerful. Han's innovative new style derives from this effect of knife-carved lines in brushed calligraphy.

FIG. 6A *Seal (detail, cat. 6)*

FIG. 6B *Gui (detail, cat. 6)*

FIG. 6A

FIG. 6B

CAT. 6

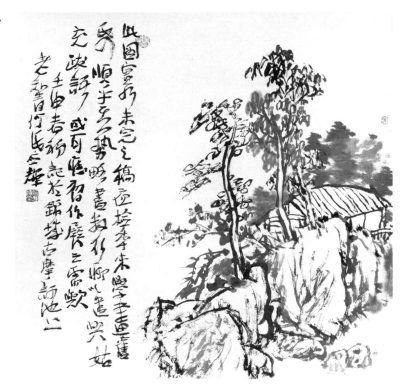

HE YINGHUI

Born in 1946, He Yinghui began learning calligraphy when he was six years old. During the Cultural Revolution, he went to the countryside as an educated youth and worked under the labor-reform movement. Even in such adverse circumstances, he continued practicing calligraphy. Currently, he is the president of the Sichuan Province Calligraphy Association as well as a member of the standing council of the Chinese Calligraphers' Association.

7. LANDSCAPE, 1992

Ink on paper, 54.5 x 56.5 cm.
Seals: "He," "The Seal of He," and "The Seal of He Yinghui"

> *This painting is actually not completed. Go with the style. Tonight I simply painted a number of lines on old paper, following the natural movement, just to please myself. So I wrote down an inscription, just as an exercise. In the spring of the year of Renshen, recorded at the ancient Mohechi. An old educated youth, He Yinghui.*

As the inscription states, this work is an unfinished sketch. Instead of continuing the painting toward the left, He Yinghui wrote a few lines of very concentrated characters to complete the composition. That an inscription must be consonant with the style of the painting has been a basic requirement of Chinese painting and calligraphy—thus the artist's postscript: "go with the style." He establishes a relation between text and image through a similar use of line. The tree trunks, the roof of the house, and in particular the bold lines forming the major contours of rock are all written with a vigorous and dynamic calligraphic touch.

Ink on paper, 60.5 x 75.7 cm.
Seal: "Shechao Ren"

The meaning of *bai mu* is *bai yan*, "supercilious look." These characters are chosen from the phrase "looking down upon chicken and insects (or bugs) superciliously," which appeared in an article by Lu Xun, "Crying over Fan Nong."[4] Chicken and insects refer to mean individuals and vicious forces, and the statement expresses disdain for contemporary power.

FIG. 8A FIG. 8B

FIG. 8A *Bai, from Zhang Menglong Stele (A.D. 522)*

FIG. 8B *Mu, by Xu Shen (d. A.D. 120), from Shuowen*

 In this exquisitely composed contemporary calligraphy, the structure of *bai* on the right is standard script (cf. FIG. 8A), while the construction of *mu* on the left is seal script (cf. FIG. 8B). The writing style of both combined, however, is cursive script, which links the two words. Between the straight, prominent vertical line in *bai* and the curved line in *mu*, between the dot in the pictographic character *mu* and the rest of its long lines, He effectively unites seeming opposites through his fast, forceful, and unconstrained cursive script. The seal in the lower left corner, despite its small size, exists in dialogue with the calligraphic image, lending prominence to the main topic even as it contributes importantly to the spatial articulation of the overall composition.[5]

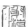

CAT. 8

9. WHITE CRANE, 1995

Ink on paper (running script), 59.5 x 100.7 cm.
Seal: "The Seal of He"

This contemporary work celebrates nature with rhythm of line and space. With only two characters, the artist brings to life the majesty of a crane lifting off the ground: the simplicity and the dispersed line in *bai* (white), the character on the left, and the contrasting flying, winding lines in *he* (crane) on the right. Caught between the two dichotomous characters, the curved linear white space is pulled into the emptiness above, similar to the dramatic moment of a crane lifting off the ground in flight. The emphasis here is on movement and flow. The flowing rhythm unites nature and the spirit of the line.

CAT. 9

10. COUPLET, 1994

Ink on paper (running script), 2 sheets, each 176.5 x 45.0 cm.
Seals: "The Seal of He," "The Seal of He Yinghui," and "Shechao Ren"

> *Feeling on the sea,*
> *Life in the mountains.*

Since 1986 He Yinghui has worked on combining the techniques of "bei" and "tie." "Bei" refers to calligraphy carved on cliffs and stone stelae produced in great numbers during the Han and Northern Wei (A.D. 386–534) (FIG. 10A). This type of calligraphy is generally expressive of magnificent scenes. "Tie" refers to characters, usually in small formats such as letters, written on paper. The lines inside the characters, smooth and continuous, show the brush technique of the artist directly (FIG. 10B).

He Yinghui adopts the squared "bei" brushwork, combining this with the continuous movement of "tie," thus bringing together the hallmarks of two traditions. For example, in *shan* (mountain), the twisting squared-brush moves from top to bottom thickly and powerfully, yet the line's edges still preserve the trace of erosion common in "bei" carving. The short vertical brushstroke on the left echoes the slightly tilting horizontal line in the middle; it is as if the brushed-out hollow strokes were created with a half-dry brush. The parallel lines driving toward the right, quickly flying up and then skipping down, demonstrate their own continuity, thereby combining the expressive forces of both "bei" and "tie."

CAT. 10

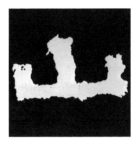

FIG. 10A

FIG. 10B

FIG. 10A *Shan, from Zhongyue Lingmiao Bei (A.D. 531)*

FIG. 10B *Shan, by Su Shi, from Shusu Tie*

LIANG YANG

Liang Yang was born in Beijing in 1960. After graduating from People's University in 1989, he worked as an editor at *Zhongguo Shufa* (Chinese Calligraphy) magazine. He went to Paris in 1990 to pursue his Ph.D. in art theory. Six years later, he returned to China to work as executive editor of the magazine *Zhonghua Ernü* (The Chinese Descendants). In addition to being a calligrapher, Liang is also a scholar of literature and Beijing opera.

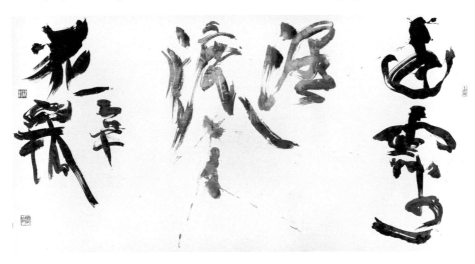

CAT. 11

11. IN A STATION OF THE METRO, 1997

Ink on paper (cursive script), 68.7 x 137.4 cm.
Seals: "Extreme Truth," "Liang Yang," and "Following Nature"

> *Faces in the crowd,*
> *Petals on a wet, black bough.*
> —Ezra Pound (1885–1972)

The text of this calligraphy is a free translation of Pound's two-line poem:

> *The apparition of these faces in the crowd;*
> *Petals on a wet, black bough.*

Liang deals with this poem by combining older calligraphic styles and modern expressive methods. In the first column on the right, the characters *you ling* (faces in the crowd) are drawn with violent pressure to convey a sense of physicality. To the left, the sudden stops and starts and the drastic shifts in the angle of the brush capture the spirit of the parade of diverse faces that the poem evokes.

In the center part, however, the ink shifts from dark to light. As the poem progresses, there is increasing variation between wet and dry brushwork. The resulting rhythmic rise and fall produces a spatial effect, emulating through the calligraphic line the poem's apparition of faces emerging from and disappearing back into the crowd. The intensity of the final characters gives visual form to the wetness and blackness of Pound's second line. Liang's style is remarkably successful in conveying the consistent unity of purpose (or purposelessness) of Pound's subway experience.

Born in 1937, Liu Bingsen spent his childhood in the suburbs of Tianjin, Haiziwa Village, and calls himself the "Villager of Haiziwa." He has become famous for the publication of his calligraphy in *Lu Xun's Poems* during the later stage of the Cultural Revolution. Known as an expert at clerical script, he is now vice president of the Chinese Calligraphers' Association.

12. SPIRITUAL BRUSH MOUNTAIN, 1997

Ink on paper (clerical script), 179.0 x 96.3 cm. Seals: "Style of Both the Han and Wei Dynasties," "The Year of Dingchou," and "The Seal of Liu Bingsen"

CAT. 12

The gentle fog and the light clouds roll and expand,
The blue sky and the green water are like two flat sheets of paper.
I'd like to use the force of the Spiritual Brush Mountain Peak
To write the huge clerical script of my heart.
—Written at the Longqing Gorge, Spiritual Brush Mountain, Liu Bingseng.

FIG. 12A *Rubbing from Yiying Stele (A.D. 153)*

FIG. 12A

In this scroll Liu follows the style of the Yiying Stele (FIG. 12A). The squared structure of each character is essentially contained within a rectangle. External shapes are even and internal structures are closed. Liu's clerical script maintains the characteristics of this style. Yet the spacing between columns is tighter than in the traditional work, while that between the characters is greater. The strokes are balanced. The long horizontal lines are wavy and thicker, written with the slanted tip of the brush; the vertical lines made by the centered tip of the brush are thinner and direct. In fact, most lines are straight and simplified, and the traditional decorative shapes, called *cantou yanwei* (head of silkworm and tail of swallow), have been abandoned.[6]

The negative spaces within the characters of Liu's calligraphy are clearly defined and symmetrical. The energized spaces form geometric figures. Emphasis on the space around lines distinguishes Liu's clerical script from more traditional approaches. Inspired by the calligraphy of the Northern Wei Dynasty, Liu's brushwork conveys the texture of carving. His seal, stamped in the upper right of the scroll, proclaims both his artistic ideas and methods: "Style of Both the Han and Wei Dynasties." His style, in its square brushwork, is indeed a synthesis of Han Dynasty clerical script and Northern Wei style. But Liu often enriches the solemnity of clerical script by quickly brushing a conspicuous cursive "flying white," an ornamental flourish that adds a personal spontaneity to the basic geometry of the character.

13. TRIP TO MOUNTAIN WEST VILLAGE, 1997

Ink on green paper, 133.8 x 66.2 cm.

Seals: "The Sea Village Farmer," "The Year of Dingchou," and "The Seal of Liu Bingsen"

Don't laugh because it's muddy end-of-the-year wine brewed in country homes;
The harvest was good—to make the guest linger, fowl and pork aplenty.
Mountains multiply, streams double back—I doubt there's even a road;
Willows cluster darkly, blossoms shine—another village ahead!
Pipe and drum sounds tagging me—spring festival soon;
Robe, cap of plain and simple cut—they honor old ways here.
From now on, if I may, when time and moonlight allow,
I'll take my stick and, uninvited, come knock at your evening gate.[7]
—Lu You (1125–1210)

Known as a master of clerical script, Liu also has a solid foundation in standard script. He learned it from his childhood teacher who taught him to copy, using Yan Zhenqing's (A.D. 709–785) calligraphy (FIG. 13A) as a model. Although he later changed to the clerical script of the Han Dynasty, he has spent much of his career practicing standard script, particularly the style of Yan Zhenqing. Yan's standard script, however, is not the same as that of the preceding Wang Xizhi school (FIG. 13B), whose graceful style dominates the history of standard script. Yan Zhenqing reformed that model by adding seal strokes and clerical script; thus challenging Wang's influence, he initiated a new grand and vigorous style. Liu absorbed a sense of strong and solid structure from Yan, but he gave up his ornamental lines. The end of the third horizontal line from the top in *Trip to Mountain West Village* is very smooth. Without the shape of the "head of silkworm and tail of swallow," Liu's strokes are straightforward, neat, full, and round. In this, he explores standard script between the styles of Wang and Yan (FIG. 13C).

FIG. 13A

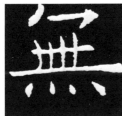

FIG. 13B

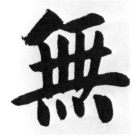

FIG. 13C

CAT. 13

FIG. 13A *Wu, by Yan Zhenqing, from Yanjia Miao Stele* (A.D. 780)

FIG. 13B *Wu, by Ouyang Xun, from Jiucheng Gong* (A.D. 632)

FIG. 13C *Wu (detail, cat. 13)*

CAT. 14

FIG. 14A FIG. 14B

14. WRITTEN AS A GUEST, 1997

Ink on tan paper (cursive script), 132.0 x 33.5 cm.
Seals: "The Sea Village Farmer," "The Year of Ding-chou," and "Bingsen's Painting and Calligraphy"

> *Lanling liqueur has a warm golden scent,*
> *Served in a jade cup, it shimmers amber.*
> *If only you, my host, could make me drunk,*
> *I'd not know anywhere that wasn't home.*[8]
> —Li Bai

In his clerical and standard scripts, Liu Bingsen adopts many elements from calligraphers of past ages. It is difficult, however, to detect his reliance on any particular model. Liu pioneers a technique in which lines are created through formal relationships rather than directly through the strokes themselves. Traditionally, the lines in cursive script are curved, which often expresses the movement of the calligrapher's emotion (FIG. 14A). Yet Liu's stroke combines straight and curved lines: the latter transforms into the former. In the character *yu* (currcuma aromatica, or luxuriant), for instance, the horizontal and vertical lend an insistent rhythm to the flowing cursive script (FIG 14B). Furthermore, some words are written very large, presenting a striking contrast to the smaller ones around them. Instead of seeming artificial and abrupt, this contrast is balanced by quick strokes, which extend the energies of the dominant characters to the words that follow. The boldness of Liu's style enhances the poem of Li Bai, brightening the literary image.

Liu Tianwei was born in Shanghai in 1954. In 1985 he received his M.A. at the School of the Museum of Fine Arts, Boston. His works have been exhibited in China, Japan, and the United States.

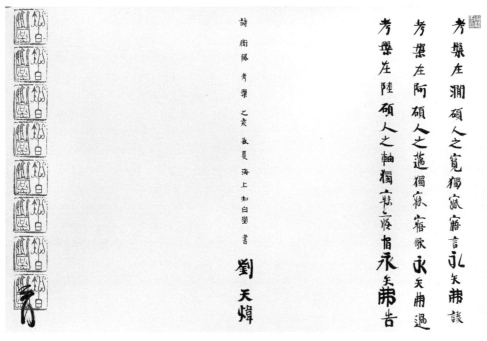

CAT. 15

15. A HAPPY HERMIT (KAO PAN), 1995

Ink on paper (running script), 46.5 x 69.0 cm.
Seals: "Yu Long Shi" and "The Studio of Understanding Space"

> *By the stream in the valley his hut he has reared,*
> *That man tall and stout, looking free from all cares.*
> *He lives all alone; he sleeps, wakes, and then talks;—*
> *And ne'er to forget what he prizes, he swears.*
>
> *In the bend of the mound his hut he has reared,*
> *That man tall and stout, gay and lightsome of heart.*
> *He lives all alone; he sleeps, wakes, and then sings;—*
> *He swears from this spot he will never depart.*
>
> *There on that level height his hut he has reared,*
> *That man tall and stout, who himself so contains.*
> *He lives all alone; he sleeps, wakes, sleeps again;—*
> *He swears he'll ne'er tell what in his mind reigns.*
> *That man tall and stout, gay and lightsome of heart.*[9]

"A Happy Hermit" ("Kao Pan") is one of the poems in the *Shi Jing*, compiled in China 2500 years ago. The earliest known anthology of verse, the *Shi Jing* contains 305 poems dating from 1713 B.C. ("The Rise of Shang") to 505 B.C. ("Comradeship").

Liu divides the work into three sections, with the first three columns containing the text. The single column in the center has an original inscription by the artist and his signature, all executed in small characters; the signature is somewhat larger than the inscription and matches in size the text on the far right side. The column on the left side is stamped eight times with the same seal, "The Studio of Understanding Space." The blank space between, which is crucial to the overall image, dominates three-fourths of the paper surface and demonstrates the Daoist philosophy: emptiness is at the heart of everything.

The arrangement of the text is unique. The same characters are often repeated in the horizontal plane. In general, calligraphers deal with repetition by drawing the same characters in various shapes, and Liu Tianwei shows great variety in the execution of these repeated characters. Too much variety, however, can create an appearance of disunity, disorder, and chaos. To maintain consistency across the composition, Liu therefore avoids abrupt changes; rather he creates smooth transitions between large and small, thick and thin. Furthermore, the emphatic differentiation among repeating characters is offset by their placement on slightly different planes, one a little higher, one slightly lower, which preserves a sense of contrast while lessening its potentially disruptive effect; an example is the thrice-repeated *yong* (always), appearing as the fourth character from the bottom in each column.

The other chief characteristic of Liu's work involves the writing order and the reading order. Usually in calligraphy, especially in running and cursive script, the reader follows the characters in the same sequence as the calligrapher writes them: from top to bottom. In this work, however, since there are many repeated characters appearing in the same horizontal row, the eye may feel compelled to wander off in this direction. Although Liu wrote his calligraphy from top to bottom, the reader's attention may also move from side to side, independent of the writing order (and of the standard reading of the text). Liu himself seems conscious of this potential deflection and, in fact, uses it to his advantage: he is able to introduce a somewhat jarring change of character size as he moves down the column, knowing that much of the power of this otherwise disconcerting effect will be shifted to one side, countered by the horizontal line of repeated characters.

16. THE LAMENT (LI SAO), 1995

Ink on paper (cursive script), 46.5 x 69.0 cm.
Seals: "The Studio of Understanding Space" and "Liu"

> *Swift jade-green Dragon, Bird with Plumage gold,*
> *I harnessed to the Whirlwind, and behold,*
> *At Daybreak from the Land of Plane-trees grey,*
> *I came to Paradise ere close of Day.*
> *I wished within the sacred Grove to stay,*
> *The Sun had dropped, and Darkness wrapped the Way;*

The Driver of the Sun I bade to stay.
Ere with the setting Rays we haste away.
The way was long, and wrapped in Gloom did seem,
As I urged on to seek my vanished Dream.[10]
—Qu Yuan (340–278 B.C.)

"Li Sao," one of the most remarkable poems of Qu Yuan, ranks among the great works in the history of poetry. Qu was a thinker and statesman, as well as a poet. This long lyrical poem, written during the period when he had been banished by his king and was living south of the Yangtze River, expresses his love of country and sadness on exile. The cultural backgrounds of the *Shi Jing* and "Li Sao" are very different: one originated from the area of the Yellow River, while the other came from the Yangtze River. Liu Tianwei has therefore used two different styles of writing to capture the different cultural atmospheres: the *Shi Jing* was produced in a very quietist milieu, "Li Sao" in a more active one. The enormous difference between Liu's *Shi Jing* and his *Li Sao* reveals this geographical and cultural diversity.

The fundamental characteristic of the brushwork in *Li Sao* is that the tip of the brush remains in the center of the line and stroke, thus creating a round and full shape. The resulting cursive structure is dense and heavy. At the same time, there is important contrast between large and small, thick and thin. The remarkably large characters are executed in heavy and straight strokes. The contrast between these characters and the smaller ones, when viewed in isolation, may suggest imbalance; but these wide variations of size and texture are well dispersed throughout the overall composition, creating a sense of overall unity.

CAT. 16

LIU WENHUA

Liu Wenhua, born in Beijing in 1955, graduated from Capital Normal University in 1987, majoring in calligraphy. He has won several national prizes, including the Fourth National Calligraphy Exhibition in 1989 for his *Ode to History*.

17. ODE TO HISTORY, 1989

Ink on paper (clerical script), 130.0 x 66.0 cm.
Seals: "The Seal of Liu Wenhua" and "Puguang Tuya"

> *I review ancient statesmen and the government of realms,*
> *Success comes from austerity, defeat from luxury.*
> *Why embellish pillows with the amber from trees,*
> *Or use white pearls to decorate a carriage for the street?*
> —*The poetry of Li Shangyin* [A.D. 813–858], *the fall of the year of Fuchen, I write this in the capital, Beijing.*

Like every calligrapher, Liu Wenhua has studied many historical models. Among them, the Zhang Qian Stele clerical script is his main source. The Zhang Qian Stele (FIG. 17A) was carved in A.D. 186, during the Han Dynasty. Since Zhang Qian Stele construction and strokes are angular, and its character shapes are flat, square, and even, the style might at first glance seem simple. The more it is studied, however, the more fascinating it becomes. This is due, at least in part, to the complex inner structure of these characters. To better understand this stele and its artistic meaning, as well as the whole range of Han stelae, Liu Wenhua used a magnifying glass to examine the structure, rhythm, space, and momentum of every character. From such close study, he concluded that knifework was executed over original brushstrokes. Furthermore, he came to understand the relation between the marks of the knife and the effects of erosion—due to weather and time—on the stone's surface and at the edges of each carved line. For Liu, the Zhang Qian Stele epitomizes Han clerical script, which he adopts and transforms in his own work.[11]

The vertical movement of clerical script is generally thought to be more decorative than expressive. Yet Han bamboo strips, though in clerical script, exhibit a variety of expressive elements, including freely applied gestures, uneven shapes, and cursive brushwork. They not only contain horizontal flourishes but freely drawn vertical strokes as well. Fluid and lively, most of the writings on these bamboo strips were executed by common people or anonymous artists and exhibit elements that professional calligraphers have come to admire for their naïveté. Han bamboo strips anticipate a modern search for freedom, liveliness, and expressive form. The innocence of these bamboo strips can be adopted and recreated; however, writing more in cursive than clerical script, contemporary calligraphers transform this ancient practice.

This tendency is readily observable in the work of Liu Wenhua. Four columns, suggesting bamboo strips, form the backgrounds of the characters. The bold expanding stroke of the character *xian* (good statesmen) still retains the style of bamboo writing. The beginnings of

CAT. 17

FIG. 17A

FIG. 17B

FIG. 17A *Guo, from Zhang Qian Stele*

FIG. 17B *Guo (detail, cat. 17)*

all strokes, thoughtfully executed and varied, combine sharp, blunt, and round points. The brush moves vividly, trembles subtly, yet seems to flow less artificially than many strokes found in Qing Dynasty clerical script (cf. FIG. IX). The line is dignified. As for his construction, the center of gravity is in the dense, lower part of the character, while the upper part is more exposed and open, as in *you* (from), the first character in the second column. Liu's approach, however, remains varied: the upper part may be thick while the lower part is thin, or vice versa, giving every character a different structure. In composition, the shape of characters may conform to different geometric models—

square, round, triangular, trapezoidal, and so on—

which alter the basic rectangular shape of clerical script. Some characters exhibit dry lines in cursive script, where the ink seems to disappear at the end of a stroke and appear again, such as *guo* (country) (FIG. 17B). Alternating between dry and wet characters in this way creates a spatial effect as well as a rise and fall of strong accented rhythms, a technique rarely seen in the history of clerical script.

LIU ZHENGCHENG

Liu Zhengcheng was born in 1946 in Sichuan. Through independent study, he has become a serious scholar and successful calligrapher. He is the editor of the well-known *Zhongguo Shufa Jianshang Da Cidian* (Encyclopaedia of Connoisseurship of Chinese Calligraphy), of *Zhong-guo Shufa Quanji* (The Compilation of Chinese Calligraphy), and of *Zhongguo Shufa* (Chinese Calligraphy), a leading journal of contemporary calligraphy. He has organized many major exhibitions, and his own calligraphy and ideas have deeply influenced the direction of modern Chinese calligraphy.

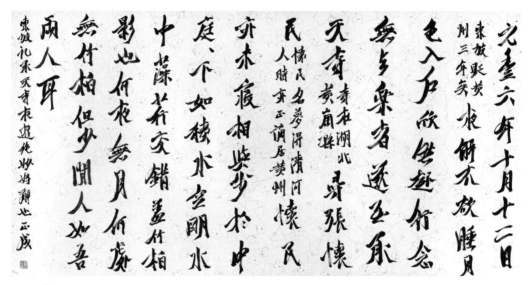

CAT. 18

18. NIGHTTIME JOURNEY TO CHENGTIAN TEMPLE, 1997

Ink on patterned paper (running script), 68.0 x 136.0 cm.
Seal: "The Seal of Liu Zhengcheng"

> *In the year of Yuan Feng, on the twelfth day of the tenth month, Dongpo had been demoted to Huangzhou three years before. At night I undressed and was about to go to sleep. The light of the moon entered the window, and I happily went out on a walk. I was thinking about the lack of joyful company. I arrived at the Chengtian Temple. The temple was located in Huanggang County of the Hubei Province. I looked for Zhang Huaimin, also known as Mengde. At that time, Zhang was also demoted to Huangzhou. Huaimin was not asleep either. Together we walked to the middle of the courtyard. Below the courtyard it was as if there was bright and pure water. In the water it seemed as if the seaweed mingled together, but actually it was just the reflection of the bamboo and pine leaves. Every night has the moon and everywhere there are pine and bamboo. There is only lack of leisurely people, like us.*
> *—Account of Dongpo [Su Shi, 1037–1101] of a nighttime journey to Chengtian Temple, which I found extraordinarily beautiful. Zhengcheng.*

Liu's early calligraphy was influenced by Northern Wei stelae. He studied these works to learn the principles of clerical script, which are manifest in the wavelike lines of his brushstrokes. Liu's running script is also influenced by the Song calligrapher Su Shi (FIG. 18A). Su's impact is most noticeable in the application, arched line, and rhythm of certain strokes. Liu's horizontal lines, however, are upward-sweeping vertical arcs. The beginnings and endings of his strokes have forceful pressure; the ends of the diagonal strokes have a particularly distinct, dense, and powerful "foot," which can be found in clerical and Wei stele script. Most striking, however, is the left foot, a historical element (FIG. 18B). Liu himself believes that the waving line alone fails to capture the classical idea that the curve is beauty and the straight line is clarity; such lines, though seemingly free, may be rigid and lack vitality. To avoid a restrained brushstroke, Liu observes the brush method of the Song calligrapher Mi Fu (FIG. 18C). He vigorously uses the four sides of the brush, allowing it to move in all directions: up, down, left, and right, and diagonally. This motion produces the central and active force within the character that distinguishes his style.

FIG. 18A FIG. 18B FIG. 18C

19. THE SOUND OF A WATERFALL, 1997

Ink on paper with gold flecks (semicursive script), 66.0 x 130.0 cm.
Seals: "The Studio of Pine and Bamboo" and "The Seal of Liu Zhengcheng"

> *The breaking of waves produces energy. The sound of a waterfall produces an atmospheric resonance. How can energy and resonance be separated? Liu Zhengcheng.*

Running and cursive, two distinct types of calligraphic script, both aspire to a freedom beyond standard script. In cursive, the structure of brush movement is more simplified, quicker, and more expressively complex than in running script. In creative calligraphy, however, these two types are not completely antithetical; artists frequently write calligraphy that is both cursive and running. This fusion can be called semicursive. Uniting cursive and running types results in a less carved and chiseled quality in the character.

In *The Sound of a Waterfall*, "waterfall" (*quan*) has a cursive construction, as does Su Shi's version (FIG. 19A). Every stroke of the character has a flexible pause, rhythm, and rich vibrancy, while still retaining the main characteristics of the running script. The second character, *sheng* (sound), is vigorously exaggerated and distorted in shape, as is apparent by comparing it with Yang Xin's (A.D. 370–442) traditional version (FIG. 19B). The beginning, top-most horizontal stroke should be short but is instead lengthened. Inclining upward from left to right, it asserts itself by forming a contrasting angle with the vertical it intersects, by

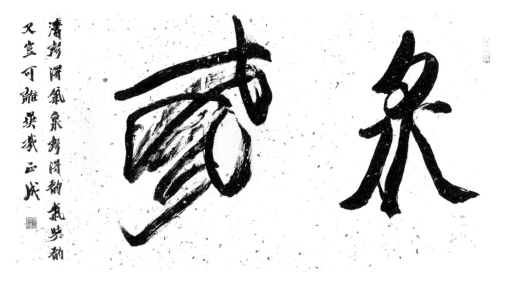

CAT. 19

having been drawn in the opposite direction to the third horizontal line from the top, and by contrasting with the structure of the downward curving lines, which loop up in a highly unconventional manner. The lower loop, drawn in an opposite direction to Yang Xin's, repeats the form and construction of the upper rightward strokes and strengthens the movement and rhythm of the upper leftward strokes, thus creating an expansive quality. These lines create balance. It is in these elements that Liu Zhengcheng's unique compositional procedures can be seen.

Usually, artists will work vigorously to strengthen the contrast between the outer form of two characters. Liu Zhengcheng, however, deliberately strives to unify the two characters by creating a common method of internal construction. In "waterfall" and "sound" both characters incline from upper right to lower left. Liu's contrast is brought about by creating a change within the character.

FIG. 19A

FIG. 19B

20. THE SPRING MORNING, 1997

Ink on paper (cursive script), 70.0 x 140.0 cm.
Seals: "The Studio of Pine and Bamboo" and "The Seal of Liu Zhengcheng"

> *This spring morning in bed I'm lying,*
> *Not wakened till I hear birds [everywhere] crying.*
> *After one night of wind and showers,*
> *How many are the fallen flowers!*[12]
> *—Poem by Meng Haoran* [A.D. 689–740]

FIG. 20A

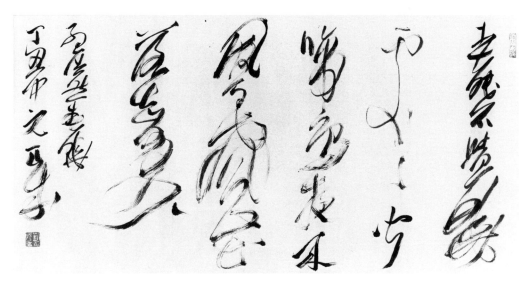

CAT. 20

Cursive—especially wild cursive—is the most brilliant of Liu Zhengcheng's several styles. Not only is his the most famous contemporary cursive script, it can also stand comparison with cursive works of the Ming period.

Tang Dynasty calligraphers created a romantic style of calligraphy called wild cursive. In this script, characters are linked in continuous strokes that move like a long curling thread, roving freely over the paper. As one character succeeds another, they become suddenly large, suddenly small, now heavy, now light, now dense, now sparse, pressing the limits of imagination. During the Ming period, cursive script and wild cursive script were developed further, bringing the cursive style to its historical zenith, especially in the calligraphy of Wang Duo.

Liu Zhengcheng's cursive script derives nourishment directly from the Tang calligrapher Zhang Xu (active seventh or eighth century A.D.) (FIG. XV) and from the cursive script of the Ming Dynasty (FIG. XVIII), which it actually seems to challenge. The speed with which his brush moves and his unrestrained style recall Zhang Xu's wild cursive script, but Liu's line is quite different. Zhang Xu's free composition depends on his use of centered-tip brushwork; he almost always keeps the tip of his brush inside the line, a type of brushwork that he referred to as *zhui hua sha* (hiding the point as if drawing in sand with an awl or pressing with a seal). Liu Zhengcheng's brushwork, on the other hand, is usually executed using the side of the brush, which shares much with his running script brushwork (FIG. XVI).

In composition, Liu's wide placement of the columns allows the crowded surface more room to breathe, creating a contrast between space and line. After his brush first touches the paper, the rhythm becomes faster and faster, and momentum gathers as the characters change from small to large, from restrained to free. The two characters *chu chu* (everywhere) occupy fully three quarters of the entire second column. His lines change from continuous to staccato, increasing the pace of their movement. In the third column, the strokes appear and disappear, dense and sparse strokes alternate. In the fourth column, the character *feng* (wind) tilts slightly from the upper right toward the lower left, in concert with the character to its left. The character *yu* (rain) shrinks and "wind" suddenly seems to enlarge. After drawing a swift

and slightly rising horizontal line, Liu turns to a vertical down stroke, which is immediately followed by a descending irregular sequence of alternating horizontals and verticals. Finally, the last column is executed in a single stroke, with a serpentine motion. The final character is especially dazzling in the lively cadence of its undulating line. The dot in this character is borrowed from Zhangcao brushwork, a type of simplified cursive that derives from clerical script (FIG. 20A).[13] As it stretches to the right, it not only strikes a widely separated balance with the diagonal stroke but also distantly yet unequivocally echoes the dot at the lower right of the previous column, punctuating a rhythmic spread of dotted accents across the field.

21. MAGNOLIAS, 1996

Ink and color on paper, 131.8 x 33.8 cm.
Seals: "The Studio of Pine and Bamboo" and "Liu Zhengcheng from Western Sichuan"

> *The spring of the year of Bingzi, when the bud is beginning to bloom. Zhengcheng.*

Like many calligraphers who enjoy painting flowers and plants, Liu Zhengcheng often depicts magnolias to represent springtime. The composition of this particular painting is built around the plant's rightward slant. The large stems overlap each other, creating a spatial core around the central diagonal. They are drawn with long, waving lines that seem almost to dance owing to their cursive nature. The short joints of each stem are executed through heavy pressure at both sides, a method borrowed from running script. Solid, bold, and stretched—this bunch of magnolias is a perfect embodiment of calligraphic lines that have been revised and reused for centuries. Clusters of swelling elliptical buds control the movement of the eye along the length of the stems, punctuating the composition and establishing its strong rhythm.

CAT. 21

Born in Hangzhou in 1960, Luo Qi graduated from the Chinese Art Institute and has remained on campus as a professor and editor. A leading figure of the postmodern calligraphy movement known as Calligraphyism, he has organized three major exhibitions of this art, in 1993, 1995, and 1997. Consisting chiefly of younger artists, this movement has had a considerable influence on the world of contemporary calligraphy in China. Continuing a trend of reaction to traditional calligraphy, which began in the aftermath of the First Annual National Calligraphy Exhibition in 1985, Calligraphyism has proved to be the most innovative aesthetic of modern calligraphy.

22. LOVE LETTER NO. 1, 1990

Ink and color on paper, 44.8 x 34.2 cm.

CAT. 22

Calligraphyism is as difficult to define here as it is for the calligraphers themselves. In theory, the term refers to a departure from modern calligraphy because it questions the tenets of traditional practices even more rigorously. In general, modern calligraphy still preserves the intrinsic structure of each character and remains an artistic form of writing. Calligraphyism seeks to alter the basic structure of the characters themselves, even if they can no longer be read as writing. Calligraphy in this sense becomes pure abstract art, essentially a Chinese postmodernism.

Luo Qi's early works harnessed various Pop Art styles in an effort to break with tradition. More recently, however, he has endeavored to escape the calligraphic line by pursuing a "universal line," emphasizing the abstract quality of each brushstroke. By avoiding any specifically Chinese calligraphic marks in his work, Luo aims at universality, at making his pieces more widely "readable" on a formal—and not linguistic—level. This exhibition draws primarily from his most recent work.

Although executed with the calligrapher's traditional tools of brush and ink, *Love Letter No. 1* challenges traditional notions of calligraphy as "character writing." The standard brushstroke order of Chinese character writing has been abandoned, resulting in the more purely abstract expression that Calligraphyism seeks. The triangular form at the top has been bisected by dropping a vertical that tapers off in the center. The two vertical strokes at the bottom are almost parallel, reinforcing each other as well as strengthening the whole; the curves in the center swirl in opposite directions. At the same time, the varying degrees of lightness or darkness of the component strokes seems to create a spatial effect. The arrangement of lines suggests Abstract Expressionism as developed in the West, but the lines themselves are drawn according to the ancient seal script method in which the tip of the brush remains always in the center of the line, producing a characteristic round shape. There are also some isolated instances of cursive brushstrokes, such as "flying white," written with a dry brush.

23. BLACKISM, 1990

Ink and color on paper, 70.0 x 68.9 cm.

Part of a series of works, *Blackism* abandons the traditional calligrapher's brush. While Luo uses a traditional Chinese character, he draws it in an unconventional stroke order. In addition, it is also composed of lines that are themselves revolutionary, emphasizing the overall composition. First, a wide flat brush was applied from top to bottom; then, a horizontal stroke was added to complete the structure in the upper left; then, smaller dots were splashed below the horizontal stroke as if hanging from it. The form to the right was created with a unified heavy-light-heavy stroke in a curving motion that also involved sudden variation of speed, producing a three-dimensional spiral effect. Finally, a heavy diagonal stroke was added to achieve overall balance.

Rejecting both the modern calligraphers' pursuit of pictorial representation of individual characters and the traditional calligraphers' adherence to ancient methods, Luo Qi has staged an artistic revolution, one that turns from the nationalistic aspects of traditional art to embrace a more immediate expressiveness of the brush.

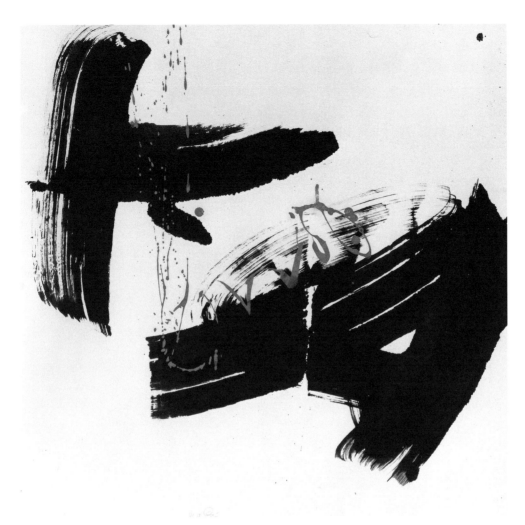

CAT. 23

24. THE ORIGINAL WORD, 1997

Ink and color on paper, 68.0 x 68.0 cm.

Here Luo Qi turns calligraphy into an abstract art by breaking with the tradition of one-pass execution, by bringing together line and color, and by employing a combination of mediums. In this abstract form both square and round strokes avoid the true vertical or horizontal. The lines are most often slanted; cut off by the picture's edge, they imply extension beyond the field. The picture's overall balance is achieved not through symmetry between large areas but through the balance and coordination of short lines and the interplay of light and dark colors. Because Liu has done away with the character as symbol, he has also emptied it of representational content. Without vestigial recollection of its origins in a textual tradition, the mark stands on its own, as pure graphic expression.

In going beyond the line and the tools of the calligrapher, making calligraphy into an abstract art, Luo Qi acknowledges that he has been inspired by Western art; his first prints, for

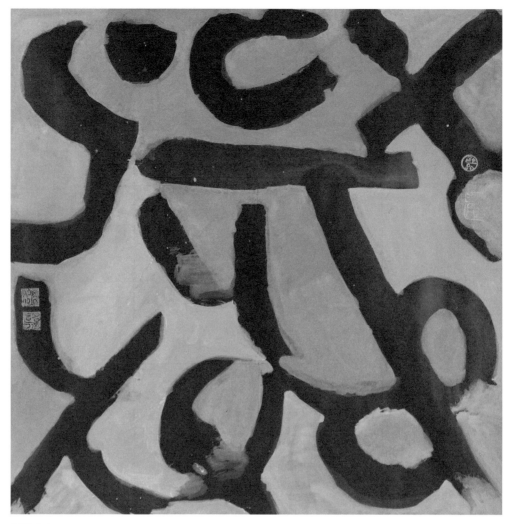

CAT. 24

instance, were influenced by Kandinsky. He states quite clearly that he looks at Chinese calligraphy as a form of abstract painting. He considers his a purely visual art, one that transcends national and regional limitations. A Chinese observer may indeed be perplexed by Luo Qi's weavings of color and ink, while to Western eyes they often appear to have an Eastern tone.

Ouyang Zhongshi was born in Taian, Shandong Province, in 1928. He is now a professor at Capital Normal University. In addition to his renown as a calligrapher, Ouyang is also proficient in philosophy, literature, and Beijing opera. In 1985 he was the first to establish calligraphy as a major field at the university, and thereby introduced the art into higher education; he made calligraphy education systematic and academically rigorous. In 1995 he recruited the first class of Ph.D. students in calligraphic research.

FIG. 25A

FIG. 25B

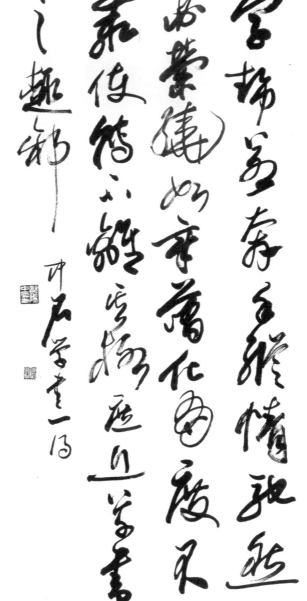

FIG. 25A *Shi (detail, cat. 25)*

FIG. 25B *Shi, by Wang Xizhi, from Chengqingtang Tie*

25. ZHONGSHI'S UNDER-STANDING OF THE CURSIVE SCRIPT, 1997

Ink on paper (cursive script), 138.0 x 69.0 cm.
Seals: "The Seal of Ouyang Zhongshi" and "Getting Older and Getting Clearer"

> *The character's momentum is like running,*
> *The hand indulges and the emotions flow.*
> *Yet the twisting of the line must follow order:*
> *Do not make the turning movement strange,*
> *Do not get away from the pattern.*
> *This is the cursive flavor.*
> *—Zhongshi's understanding of the cursive script.*

CAT. 25

Ink on paper (running script), 138.0 x 69.0 cm.
Seals: "The Seal of Ouyang Zhongshi" and "Getting Older and Getting Clearer"

> *Use upright structure to achieve momentum,*
> *Moving slowly, like the moving cloud in the sky,*
> *Like rolling water of the stream.*
> *Yet the movement must be peaceful,*
> *The spiritual focus must not lose balance.*
> *This is the goal of the running script.*
> *—Zhongshi's understanding of running script.*

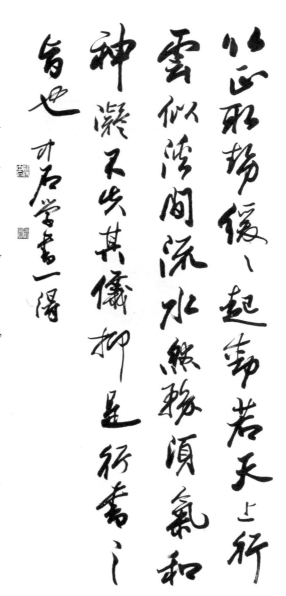

In this work and the previous one, Ouyang's calligraphy is made with a brush of long, soft goat's hair. He holds his brush at the top of the handle and favors pale tones. Since the hand is far from the tip of the brush, and the ink is watery, writing done in this way is difficult to control.

Although Ouyang's style draws on the tradition of Wang Xizhi and Wang Xianzhi, it departs from the style of the "two Wangs" in the more exaggerated structure of his characters. The proportions of the characters are changed: they tilt and begin to converge on the left or right, as for instance, in the character *shi* (momentum) (FIG. 25A). Ouyang shifts the lower element to the far right, disrupting the classical balance of the character as it appears in the work by Wang Xizhi (FIG. 25B). Ouyang also transforms the rhythm of Wang's calligraphy. The last stroke on the left part of character merges with the first of the right part to form a very thick and solid stroke; what would have been a separated line is now connected. The rhythm of strokes within each part of the original three-part character has been altered: three strokes in the first part have become two relatively thin lines crossing each other, one vertical,

CAT. 26

the other horizontal. The second part of this character, originally drawn in two strokes, becomes a triple beat, formed from lower left toward the upper right. Finally, the third part of this character is drawn in two strokes. In this way, the rhythm of the character is changed in a fundamental way. This rhythmical change is also the result of structural changes, such as squared brushstrokes and the infrequent use of a sharp-pointed brush; the lines are thick rather than fine. These changes reveal Ouyan's adaptation of Northern Wei writing style into cursive, not only its thick lines but also its stable elements, which he consciously uses to balance the flowing cursive. Ouyang was fully aware of the opposing effect of precipitousness and stability: the former is meaningless without the existence of the latter. At the same time that he was using the heavy lines of Northern Wei stelae, he also exploited the square-shaped structures and dots from Zhangcao cursive. The last stroke of *ben* (running), the fourth character in the first column, is raised up with a heavy brush, emphasizing the pauses and rhythm of the moving brush.

SHAO YAN

Shao Yan was born in Shandong Province in 1960. He was awarded first prize in a young and middle-aged national calligraphy exhibition in 1995 and again in 1997. Unlike some other modern calligraphers, Shao has not abandoned the use of characters in his work and continues to explore the potential of classical calligraphy. But he also uses ideas drawn from Western art, in order to discover his "selfness" and to achieve his goal of "constructing a skyscraper by finding a path between the traditional and modern."[14]

CAT. 27

27. SEA, 1991
Ink on paper, 96.0 x 89.0 cm.

As abstract as it may appear, Shao Yan's *Sea* (*hai*) is executed in the cursive structure (cf. FIG. 27A). After forcefully applying the beginning dot to the upper left corner, Shao quickly brushes toward the bottom of the field; he then sweeps toward the upper edge, only to move down, then up again, before descending into a swirling twist that suggests the churning violence of a breaking wave. The form's image perfectly captures the nature of a turbulent sea.

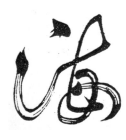

FIG. 27A

In *Sea* a variety of intense movements combine into a dynamic composition. Shao follows the basic structure of the character, but is further inspired by its meaning. Through many washes, he creates three types of ink deposits: dry, moist, and dense. His dry brushstroke resembles the froth and spray of a breaking wave; the moist ink resembles the actual body of a wave; and the dense brushstroke evokes the unknown elements of the deep, which touch the imagination.

28. SURROUNDING, 1991

Ink on paper, 68.0 x 68.0 cm.
Seal: "The Seal of Shao Yan"

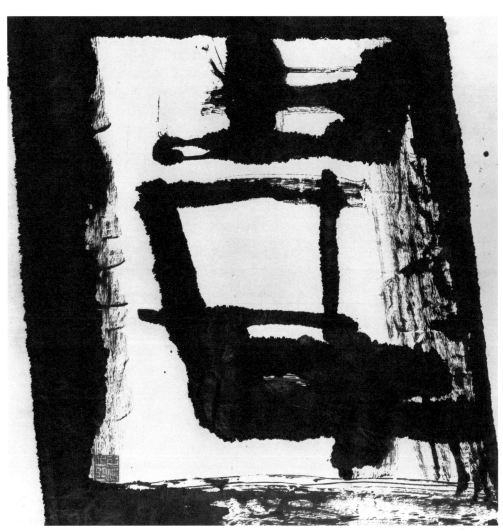

CAT. 28

In contrast to the round structure of *Sea*, the line that frames *Surrounding* (*wei*) is executed in squared brushwork. This effect, while based upon the character, is achieved not by using a traditional pointed Chinese brush but rather with a wide and flat Western brush (cf. FIG. 28A). Shao Yan takes great pains to organize the structure. The two opposing heavy vertical lines framing the work are drawn parallel. The top and bottom lines both continue beyond the edge of the paper and thus appear cropped or abbreviated, while

FIG. 28A

FIG. 28A *Wei, by Yu Shinan (A.D. 558–638), from Kongzi Miaotang Stele*

the right and left lines incline from upper left to lower right, creating two wedge-shaped white spaces. These lines are not truly calligraphic but rather are inspired by the work of Franz Kline (FIG. XXIX). The strokes applied inside this frame exhibit many traditional calligraphic features. For instance, the two horizontal lines in the upper part are executed in centered-tip brushwork with "flying white," while the two horizontal lines, drawn in moist ink beneath, bleed and merge into one heavy stroke. These horizontals all move toward the right. Two verticals are drawn at the top of the image: one, brushed near the center, roughly parallels the two long, slanting lines that frame the image. The other vertical, to the right, inclines upward from left to right, thus countering the direction of the central vertical and the two long framing strokes. Toward the bottom, beneath the dense double horizontals, a thick, short vertical line is dropped toward the lower edge of the field. Rather than being placed centrally, as the traditional character might have suggested, it has been drawn significantly off-center, toward the right. Furthermore, what would have been a square, just above the thick double horizontal lines, is here written as a trapezoid that tapers toward the bottom. Although Shao includes surprises in the form of incongruities and asymmetries throughout this work, he nonetheless achieves remarkable balances, especially in the dialogue between the trapezoid and the four thick strokes that border the character on all sides. The outlines of this work seem to suggest an ancient city wall, surrounding other forms—a family, or a people constrained—all of which seek to escape their impenetrable "surroundings."[15] Shao Yan's ingenious use of line thus suggests a real object. Unlike *Sea*, however, *Surrounding* remains more abstract.[16]

29. NONBEING, 1991

Ink on paper, 68.0 x 68.0 cm.
Seal: "The Seal of Shao Yan"

Shao Yan's *Nonbeing*, not unlike *Surrounding*, has philosophical implications. Two horizontal strokes descend from the upper left, while a third horizontal ascends from the lower left. In contrast to the standard form of the character *wu* (FIGS. 13A–C), whose horizontals are largely parallel, this line almost touches the dark horizontal above it. The fourth horizontal line, at the bottom, is flat, yet it seems three dimensional due to the contrast of dark edge and lighter interior, created through a wash technique. Of the three verticals, two are parallel; these

frame a third, middle member, which inclines at a slightly different angle. These lines support the heavy horizontal structure above. The large, empty spaces contained and created by the wash strokes at bottom symbolize nonbeing for Shao, the more important term in the Daoist duo of being/nonbeing (see p. 20).

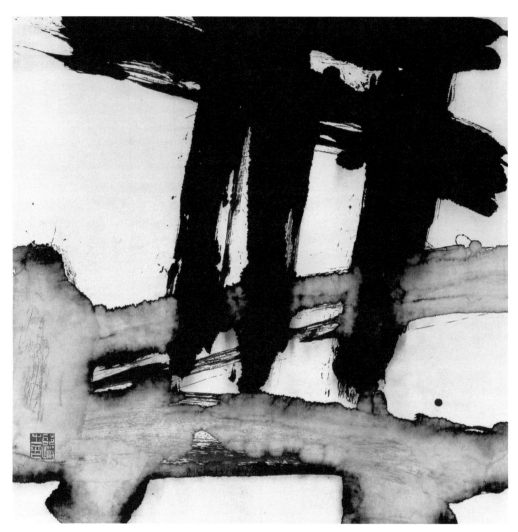

CAT. 29

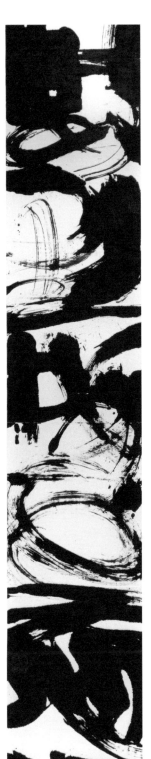

Ink on paper, 276.0 x 48.0 cm.
Seals: "The World of Water and Ink," "Shao Yan's Ink Mark," and
"The Shandong Man"

A work with "more characters" (*shudian meihua tiandi xi*) is not
easily organized. It requires a thorough grounding in "a few char-
acter" calligraphy as well as a skillful technique. Combining tem-
poral and spatial aspects into a system is Shao Yan's main concern:
this distinguishes his art from that of other modern calligraphers.
Shao draws full and thick strokes which radiate from the center of
the work and continue to and beyond the paper's edge. Modern
calligraphers emphasize the compositional space of the whole page
in a manner distinct from that of more traditional artists, who
tend to write characters as floating vignettes. For all its impacted
energy and apparent abstractness, Shao Yan's *Plums Alight, Starry
Night* remains legibly calligraphic. Each of its characters derives
from a cursive tradition and can be judged against such models
(FIGS. 30A–G). Regardless of how his style changes with the speed
and direction of his brush, the structure and readability of the
Chinese characters continue to inform this modern calligraphy.

FIG. 30A *Shu, by
Huang Tingjian
(1045–1105), from
Songfeng Ge
Shijuan*

FIG. 30B *Dian,
by Wang Duo,
from Wang Duo
Shijuan*

FIG. 30C *Mei, by
Du Yan (978–
1057), from
Tingyunguan Fatie*

FIG. 30D *Hua, by
Huang Tingjian,
from Li Bai Yi
Jiuyou Shi*

FIG. 30E *Tian,
by Xian Yushu
(1256–1301), from
Sanxitang Bei*

FIG. 30F *Di, by
Li Yong (A.D.
687–747), from Li
Sixun Bei.*

FIG. 30G *Xin,
by Chu Suiliang
(A.D. 596–658),
from Yiquefoxi Bei*

FIG. 30A

FIG. 30B

FIG. 30C

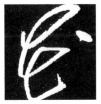

FIG. 30D

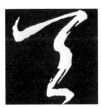

FIG. 30E

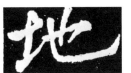

FIG. 30F

FIG. 30G

CAT. 30

SHEN PENG

Shen Peng was born in 1931 in Jiangsu Province. Currently he is executive president of the Chinese Calligraphers' Association, editor in chief of the Renmin Meishu Chubanshe (People's Art Publication House), and a well-known art critic. As a calligrapher, Shen is best known for his running and cursive scripts.

31. SOUTHERN JOURNEY, 1997

Ink on paper (running script), 100.0 x 70.0 cm.
Seals: "Shen Peng" and "Yu"

CAT. 31

Beyond the window, the fog, there is a wide expansive field,
Between the banks the peach blossom fades in and out.
From moistened moss I gather that it has rained last night,
How rare it is to hear the partridge make its strident call.
—In the year of Dingchou, I write my previous poetry,
 Southern Journey. Shen Peng.

Running and cursive script normally express rhythmic variety by contrasting upright and oblique lines and through the different sizes and thicknesses of character strokes. In Shen Peng's running script, however, there are no significant differences between the uprights or obliques or in the sizes of characters. Yet there are pronounced rhythmic changes, created by drawing the flat square characters on an incline from upper right to lower left, with virtually all characters leaning in the same direction.

Similar characters can be found in the epitaph of Zhang Xuan of the Northern Wei Dynasty, inscribed in A.D. 531 (FIG. 31A). In the epitaph, there is much space between the characters, but the columns are closely linked; at the same time, many strokes extend to the left or to the right, stressing horizontal movement. Shen Peng's calligraphy is influenced by the Northern Wei epitaph, but he transforms the horizontal into an incline, and the resultant structure enhances the rhythm and power of the movement. In particular, by changing the method of the Northern Wei script, a branch of standard script, Shen's running script emphasizes not the shape of the characters but rather the individual lines, while keeping the shape of the characters almost identical.

Most epitaph inscribers were exceedingly particular about the execution of the stroke, especially the square strokes that express solid power. Yet the lines of Shen Peng's running script are steady, smooth, and reserved. These qualities control not only the soaring lines but also the powerful, inclined movement of the characters, thus establishing an overall balance.

FIG. 31A

FIG. 31A *Rubbing from Zhang Xuan Stele*

Ink on paper (cursive script), 2 sheets, each 181.0 x 48.0 cm.
Seals: "Spring Flower and Fall Harvest," "Yu," "The Seal of Shen Peng," and "The Owner
of Jieju"

CAT. 32

"On the Stock Tower"
The sun beyond the mountains glows;
The Yellow River seaward flows.
You can enjoy a grander sight,
By climbing to a greater height.

"Out of the Great Wall"
The yellow sand rises as high as white cloud,
The lonely Great Wall lost amid the mountains proud,
Why should the Mongol flute complain no willows grow?
Beyond the Pass of Jade no vernal wind will blow.[17]

The execution of strokes and contrasting structures are important concerns for Shen Peng in both running and cursive script. Inspired by the Ming Dynasty calligrapher Wang Duo (FIG. XVIII), whose style he develops and expands, Shen achieves a balance of homologous parts in a powerful, changing cursive. The points of his strokes are very solid; in his expanding strokes especially, the pace slows, with a natural vibration, forming long S-shaped lines. He concludes many strokes with a light jerk, achieving a balance of control and spontaneity.

Sheng's rhythm is sprightly. He often stops after three strokes of the brush, or breaks after only two, forming powerful rhythms in his discontinuous lines. Sometimes he connects the last stroke of one character with the first of the following character; then he stops before continuing the second stroke of the second character with a freshly inked brush. This method produces a continuous breath and novel structures, characterized by deformed, exaggerated, perilous, yet impressively original constructions. Through a counterpoint of structure and stroke, Shen finds a creative tension as he tests the limits of the former, achieving a highly personal integration of brushwork, rhythm, and structure.

SUN BOXIANG

In 1934, Sun Boxiang was born into an ordinary peasant family in Tianjin. He suffered politically, however, since some members of his family were landowners. Deprived of the right to attend high school, he worked in a factory. Yet despite his misfortunes, he spent all of his spare time perfecting his skills in calligraphy. Today he is a well-known artist in China, serving on the National Review Committee of Calligraphy and as the vice president of the Association of Calligraphers in Tianjin.

33. PORTRAIT, 1996
Ink on paper (standard script), 69.5 x 68.8 cm.
Seals: "Boxiang" and "I am in the Work"

> *The Northern Wei Dynasty Dragon Gate stone inscription with square masculine brushstrokes is well known throughout the world. If one can produce square brushwork, one can certainly achieve density; then the beauty of the square masculine style is the dream of the calligrapher, a style that cannot be achieved through carving. This is my simple understanding of Wei calligraphy. Boxiang.*

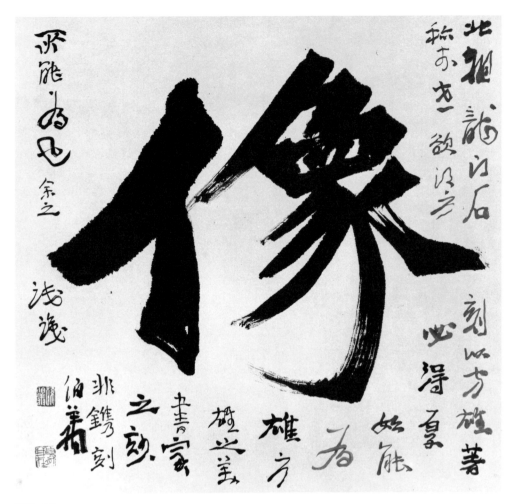

CAT. 33

The emperors of the Ming and Qing (1644–1911) Dynasties favored the calligraphy of Zhao Mengfu (1254–1322) and Dong Qichang (1555–1636). Consequently, many calligraphers modeled their works after these two artists and purposely pursued their extravagant and delicate styles. Kang Youwei (1858–1927) and other calligraphers tried to reverse this situation by focusing their attention on the stele inscriptions of the Northern Wei Dynasty, which were characterized by rough and broad strokes, varied compositions, and dynamic force. The inscription on the Dragon Gate stone thus came to serve as a special school of calligraphy.

In order to capture the spirit of Northern Wei stone inscriptions, Sun Boxiang bought and used an entire truckload of paper in his efforts to imitate and grasp the essence of the inscriptions of Shipinggong, which were carved in A.D. 498. This stele represents a calligraphy freed from clerical script. As Sun observes, "It changed the soft curves of clerical script into hard and strong strokes, turned clerical's top-hidden brush into a top-exposed brush, started its first stroke with the side of a brush in a sharp form, moved its brush flat and straightforward on paper, turned a brush vertically so that the outside of the turned stroke was straight while the inside curved, and finally resulted in a bold and forceful style of its own."[18] These are the qualities that Sun Boxiang has sought to achieve in his own work.

Portrait (*xiang*) reflects the basic spirit of Shipinggong (FIG. 33A). Sun has made innovations as well, moving the brush and composing his work differently. The leftmost vertical stroke of *xiang* is not straight, as it is in Shipinggong, but arched. The thick stroke descends, slanting toward the lower left, and, together with the first stroke, finishes with force, extending downward and outward. The first stroke toward the top of the right half of the character is slim, straight, and quick, forming a sharp contrast with the first broad stroke on the far left. All three side strokes of the right half differ in shape while maintaining a certain consistency. Compared with Shipinggong, the center of the right half of Sun's character is shifted upward, countering the downward thrust of the left half. This leaves enough space for the bow-shaped stroke as well as the final stroke, whose direction contrasts with all strokes facing the left lower corner.

FIG.33A

FIG. 33A *Xiang, from Shipinggong (A.D. 498)*

34. COUPLET, 1986

Ink on tan paper (standard script), 2 sheets, each 266.0 x 38.0 cm.
Seals: "The Seal of Sun Boxiang" and "The Studio of Studying Northern Wei"

> *Their bells and gongs robustly sound together all about the courtyard,*
> *Their caps and gowns with dignity impress the western hall.*

This parallel couplet is composed of characters that Sun Boxiang selected from Cuan Longyan, a stele erected in A.D. 458 during the Southern Dynasties period (A.D. 317–589). This tablet is an example of the transition from clerical script to standard script. It keeps some of the strokes characteristic of seal script, such as extended horizontals, undulating waves, and extensions, while transforming the original low, wide rectangular form of clerical script into a taller, narrower shape.

Sun Boxiang does not mechanically imitate Cuan Longyan. Rather, his work is a completely new creation. Sun changes not only the original structure of the characters but also the entire composition of the work. For instance, in the opening character, *jin* (gold), the two strokes intersecting at the top are straight, extended, and steeply slanted (cf. FIG. 34A). In contrast, the strokes below are short, broad. The horizontal stroke of *shi* (stone), the second character, is cut short and does not meet the next slanting stroke. The broad and heavy slanting stroke of *shi* is fused with the solid square to its lower right and, at the same time, complements the slanting stroke in the character *shang* (gown) in the opposite verse. These two slanting strokes are of two different categories and yet belong to the same system; the stroke in *shi* implies a sense of fusion and unification, while the hollow stroke in *shang* appears wild and unrefined. The lines of *qiang* (robustly), which follows and contrasts with *shi*, begin to narrow into slim strokes, and the whole composition also leans slightly. The strokes of the characters *ming* (sound) and *ji* (together) abruptly go back to being broad and heavy; they are upright and regular without even the slightest tilt. The penultimate character, *zhong* (center), is remarkably different from those before it: it is small and composed of sharply contrasting

slim and heavy strokes; its lively outline emanates a particular sense of vigor and life amid the solemnity expressed in the surrounding characters. By presenting his strokes in contrasts—long versus short, slim versus heavy, large versus small, straight versus slanted—Sun Boxiang is able to write rhythm and variation vividly into his composition. The rhythm of his work is also established through the geometric forms of the characters themselves, which include triangles, squares, trapezoids, or transformations of these shapes.

FIG. 34A *Jin, from Cuan Longyan Stele (A.D. 458)*

FIG. 34A

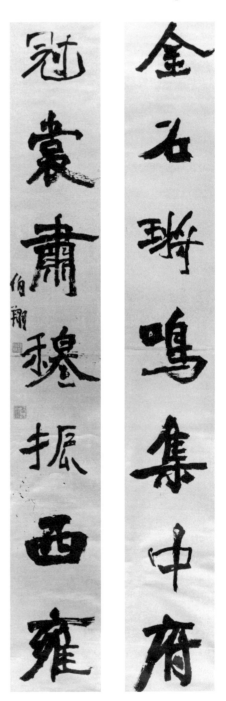

CAT. 34

Ink on tan paper (running script), 2 sheets, each 266.0 x 38.0 cm.
Seal: "The Seal of Sun Boxiang"

> *The East Mountain, suffused with splendor left by worthy men,*
> *The ocean laps against the martial valor of loyal ghosts.*
> *—On visiting Liugong Island at Weihai, in memory of Baiyang Navy, in the autumn*
> *of Bingyin, 1986, written by Sun Boxiang at the Studio of Studying Northern Wei.*

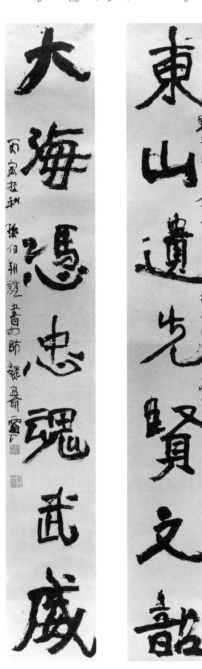

CAT. 35

Not to be found on the original Cuan Longyan Stele, the composition is an invention of Sun Boxiang, in the manner of the stele. It is highly unusual for calligraphers studying Wei stele inscriptions to tamper with the composition. Generally, they focus on the structures of the characters, trying to understand the original brushwork through the interpretation of the chisel, seeking to discern the clarity of stroke that has been eroded by time and exposure to the elements. Some calligraphers give priority to the brush, insisting that the purpose of examining the chiseled inscriptions is to improve brushwork. Others, however, have respected the importance of the chisel, believing that the clarity of engraving provided a guide to the calligrapher.

The influence of both schools of thought on Wei inscriptions can be found in Sun Boxiang's work. In the previous couplet (CAT. 34), there is a very strong implication of engraving techniques. In this work, however, Sun employs the techniques of the brush more than those of the chisel; the movements and variations of the lines and strokes are readily perceptible. Unlike Li Ruiqing, who, when borrowing engraving techniques in his brushwork, tends to show stiffness, rigidness, inflexibility, and repetitiveness (FIG. XIII), Sun Boxiang's "engraved" square brushwork is natural, smooth, without trace of hesitancy. Whether he uses a sharp-point brush or a round-point brush, Sun's brushwork moves naturally and brings forth varying and flexible strokes, even hollow strokes, that are all well coordinated with the square strokes that form the primary element in the work.

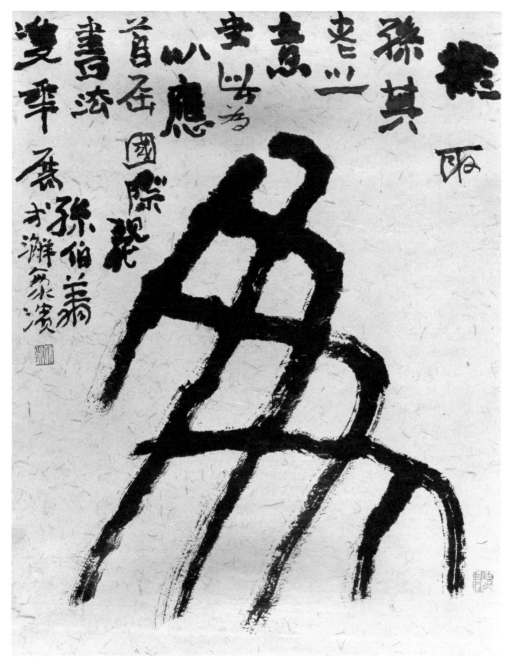

CAT. 36

36. ACTIVITY, 1995

Ink on tan paper, 89.0 x 68.1 cm.

Seals: "The Seal of Sun Boxiang" and "I am in the Work"

> *Inspired by Sun Qifeng's idea, I wrote this character for the first Biannual International Modern Calligraphy Exhibition. Sun Boxiang, written at Eastern Sea Harbor.*

The round strokes which were only a coordinating element in the previous work become the primary type of brushwork in this piece. The center of the brush tip is focused on the center of the strokes, a technique rarely seen in Sun's other works, and the resulting strokes seem similar to seal script. Indeed, as required in seal script, both the beginning and ending of a stroke receive no special trimming and show no deliberate variation in width. Although Sun's strokes here follow the requirements of seal script, they are significantly rougher. They also maintain some features of cursive, such as the strokes in dry ink, which look like aged trees or barren vines. But here there is no studied differentiation between light and heavy, no sharp contrast between speed and deliberation. Derived neither from standard script nor from clerical script, the structures of Sun's strokes in this work are very provocative. What were originally two dots on the upper right, together with the two dots at the bottom of the character, are all merged into two lines, which, parallel, move smoothly from upper left to lower right and then turn back to lower left as if they were in two facing diagonal movements (cf. FIG. 36A). These movements result in five squares which gradually increase in size toward the bottom. A conglomeration of styles, the work effectively invents a new character in the course of transforming a traditional one, achieving a modern sign of "activity" that nonetheless builds upon the symbolizing principles of ancient calligraphy.

FIG. 36A *Wei, from Zhang Qian Stele*

FIG. 36A

37. POEMS ON AN INSCRIPTION BY HONG REN [1610–1664], 1994

Ink on paper with gold flecks (semicursive script), 34.0 cm. diameter
Seals: "The Seal of Sun" and "Boxiang"

> *Drifting year by year without a house,*
> *Unrestricted in the stream and mountain.*
> *At this time if I met Yunlin,*
> *We'd build a straw hut and read peculiar books.*
> —*Poems on the inscription written by Hong Ren, one of the*
> *four greatest monks. Written by Boxiang.*

"Bei" and "tie" belong to two different systems. Generally, "bei" inscriptions—deriving from carvings on cliffs and stone stelae made during the Han and Northern Wei—connote a sense of strength, and dynamic force; "bei" characters are relatively independent or distant from each other. "Tie" characters—usually in small formats, written on paper—have a more elegant style and tend to be linked to each other, particularly in semicursive. Sun Boxiang's half-cursive cleverly combines features of "tie" with Wei Dynasty "bei". His strokes and characters are linked to one another. Even when they are not literally linked, or are deliberately broken apart, there is still an inner force that binds the strokes together, as if magnetically. Although Sun is here still using square brushwork, the style has undergone a fundamental change: the sense of power, firmness, and ruggedness has turned into a spirit of liveliness, simplicity, and naïveté. Instead of the various triangular and trapezoidal shapes seen in his previ-

ous work, odd and irregular forms come to dominate. His brush now moves rather slowly, and, with the flow of the brush, the linkage between lines and strokes is implied rather than literal. The character *yun*, for instance, still follows the structure of a Northern Wei stele (FIG. 37A), but its strokes are casually linked in such a way that they seem to be simultaneously connected and separated. The strokes in *yun* are no longer as rough or forceful as in the Northern Wei stele. Rather,

FIG. 37A

they seem to have been made by an innocent child using his brush freely and cheerfully. This naïveté, however, is not ignorance. After having undergone many years of arduous training and after arriving at a stage of maturity, Sun can now return at will to a new infancy, which is a new immaturity on a higher level, where the essence of the first two stages is well preserved while their impetuousness has been overcome. The return to the starting point of immaturity is not a simple return to ignorance; it is rather a rebirth and a sublimation. As the philosopher Zhuang Zi (active ca. 369–286 B.C.) taught, one returns to simplicity after achieving supreme splendor (*jidiao jizhuo, fugui yu pu*). And so it is with calligraphers.

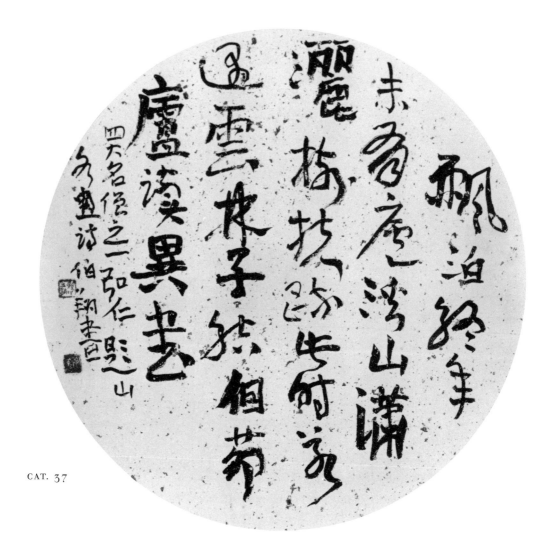

CAT. 37

Sun Xiaoyuan was born in 1955 into an artist's family and began to study calligraphy at the age of three. In 1986, she was awarded first prize at the National Exhibition of Middle-Aged and Young Calligraphers, in which more than one hundred thousand artists competed. She has won several other calligraphy competitions since then.

38. THE THEORY OF CALLIGRAPHY OF HUANG TINGJIAN, HAN YU, YU SHINAN, AND SUN GUOTING, 1995

Ink on paper with silver flecks (semicursive script), 67.3 x 42.6 cm.
Seals: "The Image of the Empty," "Sun Xiaoyun's Seal of Calligraphy and Painting," "Sun," "Water and Cloud," "Sun Xiaoyun," and Figure with Goat (image)

> *Zhang Xu's "bone breaking," Yang Zhengqing's "water traces," Wang Xizhi's "sand carving and seal pressing," Huai Si's "birds bursting from the forest and startled snakes disappearing into the grass," Suo Jin's "silverhook and scorpion's tail" are all the same sort of brushwork. [Yet they differ because] one cannot think entirely in accordance with one's hand, and one cannot write entirely according to one's thoughts.*
> *—Huang Tingjian [1045–1105], "On Calligraphy"*

> *In the past, Zhang Xu was versed in cursive script and not constrained by other techniques. If moodiness, embarrassment, grief, cheer, hate, envy, drink, boredom, or indignation moved him, it would express itself in his cursive script.*
> *—Han Yu [A.D. 768–824], "Preface for Gao Xian"*

> *I know that the Way of Calligraphy is mysterious. It turns on a chance encounter with the spirits; you cannot pursue it through effort. As to creation, you must awake to it; you cannot grasp it with your eye.*
> *— Yu Shinan [A.D. 558–638], "On the Essence of Brushwork"*

> *When working on construction at the beginning of your studies, you should try to achieve balance. Once you know balance, seek to pursue precipitousness. When you have precipitousness, then return once again to balance. At the outset, your goal is unattained. In the course [of study], you pass it by. In the end, you achieve complete understanding. And when you have complete understanding, you and your calligraphy are both old.*
> *—Sun Guoting [A.D. 648–703], "The Method of Calligraphy"*

Sun's work has a subtlety that is unique in contemporary calligraphy. Her sparse style is laden with meaning and feeling that becomes more apparent the longer one looks at her work. Sun has a solid technical foundation in traditional calligraphy, and to this she has added new understanding and insight (FIG. 38A). As an expert in running script, she follows the methods of Wang Xizhi, especially those seen in his *Shengjiao Xu* (Preface of the Sage's Education), carved in A.D. 692 (FIG. 38B). This particular work has long been used as a model for the study of calligraphy, a tradition started by one of Wang's descendants, a monk named Huai Ren, in the Tang Dynasty (A.D. 618–907). Wang's work shows both great stability and continuity, still

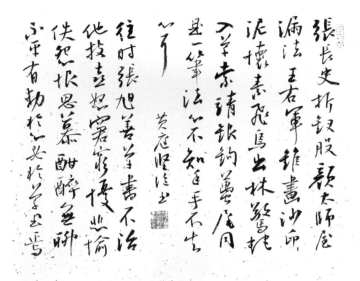

FIG. 38A

FIG. 38B

CAT. 38

evident after a thousand years. Describing his own brushwork, Wang wrote that the "shape of the character should be like a dragon or snake. The lines should be connected to each other and not stop, the edge and side (*leng ce*) of the brush should rise and fall. The brush should not make characters of the same size twice."[19] By contrast, Zhang Xu, a predecessor of Wang Xizhi, used the middle of the brush. He also employed a wildly vibrating brushwork that created another kind of rhythm: bold, heavy, and contorted rather than elegant (FIG. XV). The two different lines used by Wang Xizhi and Zhang Xu represent the two main rhythmic categories in Chinese calligraphic history.

Sun Xiaoyun's running script closely follows Wang's method. The brush tip is inclined alternately to the left and right, almost in a stirring motion, as she writes. Lines produced in this manner have wavelike edges, creating a vivid and elegant effect that, in Wang's image, recalls the movement of a dragon or snake. The liveliness depends upon the incline of the brush, never held perpendicular to the paper.

Sun's line calls to mind an expression once uttered by the thirteenth-century painter and calligrapher Zhao Mengfu: "the construction [of individual characters] changes over time, but brushwork never changes."[20] Sun changes the structure of Wang Xizhi's characters, but not the essence of his line. Her constructions show a strong contrast between thick and thin and between inclined and upright. In the character *sha* (sand), for instance, the vertical line declines from the upper left to lower right. The dots on its left and right sides are linked to each other and become one stroke. The last diagonal stroke is reduced. Pressing heavily, quickly, and then suddenly lifting, her brushwork is exceptionally sharp.

39. TWO POEMS BY TAO YUANMING [A.D. 372–427], 1996

Ink on patterned paper (running script), 2 sheets, each 21.8 x 44.2 cm.
Seals: "The Image of the Empty," "The Seal of Sun Xiaoyun," "Sun," "Water and Cloud," "Sun Xiaoyun," and Figure with Goat (image)

"Hovering Clouds"
Dense, dense the hovering clouds / Fine, fine the seasonable rain.
In the eight directions, the same dusk, / The level roads impassable.
Quietly I sit at the east window, / Spring wine—alone I take it.
The good friend is far away / I scratch my head and linger on.

The hovering clouds are dense, dense / The seasonable rain fine fine.
In the eight directions, the same dusk, / The level ways are turned to rivers.
Wine I have, wine I have— / By the east window I drink it idly,
Yearning for some one. / Neither boat nor carriage help.

The trees there in the eastern garden— / Their branches now begin to blossom.
These are new attractions vying / Each to draw my feelings out.
Among the people is the saying, / Sun and moon are on the march.
Where to find me a companion / To reminisce about the past?

Flap, flap the flying birds / Come to rest on my courtyard tree.
They fold their wings and take their ease / Calling out with pleasant voices.
Not that there is no one else / But it's you I think of most.
I long for what I cannot get / What sorrow do I harbor!

"Progression of the Seasons"
Pell-mell the seasons revolve / Still and calm is this morning.
I put on my springtime clothes / And set out for the eastern suburbs.
The hills are scoured by last night's clouds / The sky is dimmed by a film of mist.
From the south there blows a breeze / Winging over the new grain.

The wide waters of the level lake— / I rinse my mouth, I bathe myself;
Endlessly into the distance stretching— / I rejoice while I gaze.
Among the people is the saying, / It's easy to please a contented man.
I raise this cup to my lips / Happy and self-satisfied.

CAT. 39

Toward midstream I strain my eyes / Yearning for the clear Yi River,
Where youths and men study together / And singing idly go back home.
It's their tranquillity I love— / Awake or sleeping I would join them;
But the times alas are different, / Too far away to be revived.

All morning and in evening too / In my house I take my ease.
Herbs and flowers grow in rows, / Trees and bamboo cast their shade.
A cither lies across the bench, / Unstrained wine fills half a jug.
There's no reaching the ancient rulers / All I have is melancholy.[21]

Sun Xiaoyun likes to use smaller characters in her calligraphy, and her works themselves are smaller than most, such that one wonders how they can attract attention among the more expansive works in an exhibition. This preference for smaller size reflects her personal philosophy. Sun feels that, while men can more directly equate art with life and aim for grandeur, women artists are more aware of the legacy of traditional "women's arts" like cooking and embroidery (and even calligraphy) which in the old days were required of women to be eligible for marriage; women, therefore, are more apt to strive for the exquisite and pleasing. But Sun has found carrying on the tradition of the exquisite—removed, in the present day, from the need to please—to be quite liberating. In fact, she likens this type of detachment to that required in Pure Land Buddhism. This attitude may account for Sun's choice of Tao Yuanming's eremitic poetry for her subject, and it may also explain her use of less absorbent Japanese paper to support but not coarsen her delicate expressions.

40. EIGHT POEMS BY BUDDHISTS THROUGHOUT HISTORY, 1997

Ink on paper (standard script), 24.8 x 44.4 cm.
Seals: "The Image of the Empty," "Sun," and "Xiaoyun"

Where no Bodhi Tree,
There is no mirror,
Nothing, nothing at all,
There the dust will be?[22]
— "Making the Dharma *Known," by Hui Neng* [A.D. 638–713]

Each day's work, I find, is all the same,
With no one but myself to share the time.
Every task more routine than the last;
I've no complaints nor cause to celebrate.
Yet why should I pursue an empty fame
When this green hill is pristine as it is?
The Buddha's power and sublimity
In carrying water buckets and firewood bundles.
— "A Poem," by Pang Yun [Tang Dynasty]

I lean on a staff, facing this wooded meadow,
Its present so different from its past.
My hair is white from this day on.
The flowers were a better red last year.
Their charms fade as the morning dew;
Their perfume wafts away on the evening breeze.
What need to wait for them to wither,
Before one can begin to realize emptiness.
— "Making the Dharma *Known," by Wen Yi* [A.D. 885–958]

When the monk asked me why I came West,
I said, I have lived in the mountains now for I don't know how many years.
I have rewoven these straw shoes three times,
I have patched the shoulders of this hemp robe twice.
From the East Cloister I can always see snow on the West Cloister,
And upper ravine's spirit always flows on through the lower ravine.
In the middle of the night, when the white clouds part,
The moon's bright disk appears before my bed.
— "Living in the Mountains," by Ling Cheng [Song Dynasty]

Before the mountains, a field lies fallow,
Hand on hip, I question its old owner insistently.
"It been sold again and again, yet still I bought it back,
Only because I love the clear breeze wafting through those pines and bamboo."
— "Enlightenment," by Fa Yan [d. 1104]

Three feet of snow, and my gate is shut,
Year's end, and I have no heart for petty scripture.
Standing in the snow before the hall, there is no one in sight,
That fine clounded peak looks like a white-haired monk.
— "Premier Coup at Shizilin," by Wei Ze [Yuan Dynasty]

Contemplative in habit, I seek the fragrant grove
And feel the eerie darkness of the lake beneath the trees.
From out the river's mouth comes a world of roiling water,
Just as now, before the temple, seven shadowed peaks arise.
Along this misty ancient pathway, once an army dared to move,
But now, the sutra chanting daily fills these empty halls.
Indeed, the saintly teacher expounds upon the Buddha's way
While breezes blow upon the sea and call forth roaring waves.
— "Listening to Spring after Rain," by Jie Xian [Ming Dynasty]

The Zen hall stands solitary, locked in white clouds,
Sitting undisturbed on a prayer mat, all my thoughts are a void.
When I come out of meditation, night has fallen unnoticed,
And suddenly I am startled to find myself bathed in the moon's bright light.
— "Coming out of Meditation," by Jing An [1841–1921]

Standard script was perfected during the Tang Dynasty (FIG. 40A). The characters are arranged parallel to each other vertically and horizontally. The structure and strokes of the individual characters are emphasized over total composition. During the earlier Eastern Jin Dynasty (A.D. 317–420), however, the characters were not parallel to each other horizontally; consequently, the vertical columns were emphasized by the wide spaces between them. Calligraphers of earlier periods, such as Wang Xizhi and Zhong You (A.D. 151–230), all followed this method and produced heavy columns of characters (FIG. 40B) without horizontal alignment. By emphasizing this vertical arrangement, Sun Xiaoyuan pays homage to the Jin tradition.

In her depiction of each individual character, however, Sun follows not the Jin model of wavy and smooth strokes but rather that of the Tang Dynasty, particularly as represented by the novel shape and active strokes of Chu Suliang's (A.D. 596–658) structures (FIG. 40A). In contrast to Chu, however, Sun's line is more straightforward. Although the start and finish of each stroke show the strong influence of the Tang style, her lines are still smooth and elegant, in the Jin tradition. She also adds space between the strokes, as if to allow air to penetrate the structure. In this, she seems to have been inspired by Ming Dynasty calligraphers, in particular Wang Chong (1494–1533) (FIG. 40C). But she does not adopt Wang Chong's quiet stroke; instead, hers is powerful and solid. Even as she studies ancient scripts, Sun Xiaoyun discovers her own style.

CAT. 40

FIG. 40A *After Chu Suiliang (A.D. 596–658), from Yinfu Jing (detail)*

FIG. 40B *Jian Jizhi Biao (detail), by Zhong You*

FIG. 40C *Chushi Biao (detail), by Wang Chong*

FIG. 40A FIG. 40B FIG. 40C

WANG DONGLING

Wang Dongling was born in 1945 in Jiangsu Province. In 1981 he graduated from the Chinese Art Academy, where he has taught since 1989. He has also lectured at the University of Minnesota on the principles of calligraphy. While in the United States, he studied the concepts of modern Western art, which he employs in his efforts to revolutionize traditional calligraphy.

FIG. 41A Cursive script, by Xu Wei hanging scroll (detail)

FIG. 41A

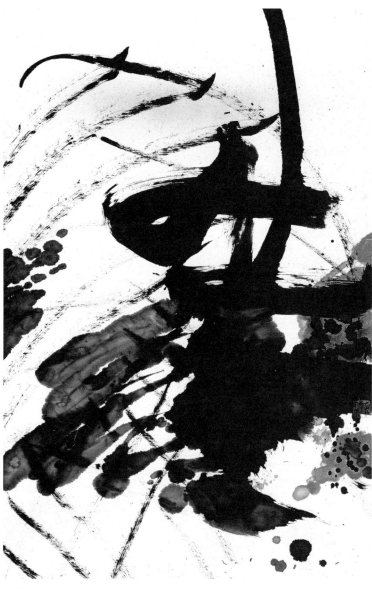

CAT. 41

41. HOMAGE TO XU WEI, 1986

Ink on paper, 100.0 x 67.5 cm.
Seal: "The Abstract Art"

Between 1985 and 1987, Wang Dongling made a number of abstract paintings, including *Homage to Xu Wei*. Xu Wei (1521–1593) was a notable Ming Dynasty painter and calligrapher, who considered his own calligraphy the most creative of all time. His lines are thickly dotted, often varying in the speed at which he applies his brush, and the overlap of his lines from left to right is breathtaking. Wang here pays tribute to Xu Wei's wide cursive script, splashed ink, and simple flowers (FIG. 41A). Inspired by Xu's calligraphy and bold, flowing style, Wang combines puddles of splashed ink and strokes seemingly abstracted from cursive script. The image thereby retains the dynamics of both painting and calligraphy; the lines might well be tree branches tossing in the wind, full of tension, rhythm, and energy.

CAT. 42

42. TRANQUILLITY, 1997

Ink on paper with silver flecks paper (seal script), 36.3 x 50.1 cm.
Seals: "Dong Gao" and "The Seal of Wang Dongling"

Tranquillity, inactivity, and letting events take their own course can be said to be the fundamentals of Daoism. These two characters, *wu* and *wei*, mean "govern by doing nothing that goes against nature." The shape of the characters is based on seal script, but the brushwork is that of cursive with passages of flowing "flying white." The outer line of *wu*, the character on the right (cf. FIG. 42A), is written in a difficult jumping technique. The line gradually changes from a full rich line to a dry, thin black and then changes back to its full black density again. The thick vertical line in the middle bisects the character. In each half, the same

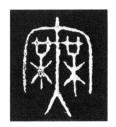

FIG. 42A

stroke is written out in different shapes. The basic direction of the whole character reflects vertical motion, which is redirected in the lines in *wei* on the left. The top curve is finished with one stroke; it not only forms a contrast with the bottom line but also coordinates with the character on the right. The top and bottom portions of *wei* form opposing diagonals and a dynamic contrast between curved lines and straight.

43. MYSTERIOUS DOOR, 1997

Ink on paper, 78.5 x 68.5 cm.
Seals: "Always Happiness," "Weixue Nianshou," "Dongling," "Wang Dongling's Seal," "The Seal of Dongling," "Comprehensive Studio," "Dong Gao," "Studio of the Sleeping Crane," and "The Seal of Wang Dongling"

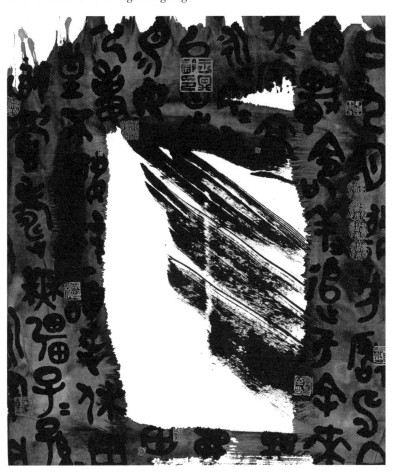

CAT. 43

This particular work was conceived as an attempt to bridge the gap between Eastern and Western artistic visions. Wang Dong has said that Eastern art seeks to grasp certain aspects of the universe through a set of essential forms, such as Chinese characters themselves, while Western art seeks to place different parts of the universe in an ideal proportion or juxtaposi-

tion, such as the golden section or Pythagorean ratios, to explain the harmony of the universe. One legend that may serve to illustrate the Eastern artistic impulse is the story of Cang Jie, who was supposed to have invented Chinese characters: after he created the characters, the "door of heaven" was broken open and it began to rain. In Wang Dongling's *Mysterious Door*, the artist first executed the contrasting black edge and white center. The "door" in the middle hints at the legend of the mysterious origins of writing. Evidently sensing a lack of dynamic tension in that brushed surface, the artist overwrote it with a remarkably large seal script; the applied calligraphy added a new dimension to the black, at once abstract yet legible, animating the surface and inspiriting the darkness. The seal characters repeat the propitious word "longevity" (*wanshou wujiang*).

44. DANCING, 1989

Ink and color on paper, 55.3 x 53.3 cm.
Seals: "The Seal of Wang Dongling" and "Hangzhou"

FIG. 44A *Wu, by Huang Tingjian, from Li Bai Yi Jiuyou Shi*

FIG. 44A

> *Zhang Xu went to see Madame Gongsun's sword dancing, and his cursive script improved greatly.*

The text in vermilion characters, a famous saying from Du Fu's poetry, declares the intimate connection of the arts. Calligraphy has often been compared to dance: the language of the body and the language of brush and ink both express inner feelings and trace the melodic flow of life. Cursive script is the richest form of expression in Chinese calligraphy, animated and surging, responding to the movements of the body.

Wang Dongling created this work after attending a modern dance performance while a guest in Connecticut. Taking a newspaper photograph of the legendary Martha Graham, he transformed it into calligraphic art by adding seals, dyed paper, and small characters written in vermilion to set off the character for "dancing," *wu* (cf. FIG. 44A). Combining Western and Eastern approaches, and clearly influenced by Pop Art, *Dancing* demonstrates the creative possibilities inherent in the encounter of two pictorial cultures. It is the work of a passionate Chinese calligrapher seeking a dialogue, a synthesis of the two traditions.

CAT. 44

45. ON SEEING THE SWORD DANCE OF A PUPIL OF MADAME GONGSUN BY DU FU, 1987

Ink on paper (cursive script), four sheets, each 235.5 x 53.8 cm.
Seals: "Great Elegant," "Hangzhou," "Studio of the Sleeping Crane," "The Seal of Wang Dongling"

In the third year of the Da Li period, the tenth month, the nineteenth day, at the home of Yuan Chi, magistrate of Kuizhou, I saw the girl Li the Twelfth from Lingy-ing do a sword dance. She was so good that I asked her who was her teacher, and she told me that she was taught by Gongsun the First, whom I saw in the third year of Kai Yuan do both the sword dance and the felt cap dance at Yancheng. Gongsun did her dance with strength and freedom. In the beginning of Xuanzong's period, Gong-sun's was the better of the two schools, Pear Garden and Spring Court. Her beauty faded as my white hairs grew, and now even her student does not look young. I saw how the movements of teacher and pupil were the same. What I have seen has in-spired me to write a poem. Once Zhang Xu of Wu, a calligrapher, saw Gongsun do-ing the West River Sword Dance at Ye, and afterward his writing improved vastly, showing both strength and rhythm.

Once there was a beauty called / Gongsun whose sword dance
Was loved by all; / Row on row the audience looked spellbound at her,
Feeling as if they were seeing heaven / Struggling against the earth;
She bent back and it seemed / There came the suns shot out by Yi;
When she rose in the air it was / As if there were gods astride
Dragons in the clouds; watching her / One could see thunder, lightning,
Storm, then quiet rays over / A peaceful sea; but soon her
Loveliness was heard of no more; / Now her art is carried on but
By this beauty of Linying in far / Kuizhou, where she dances and sings;
Talking with her I think of / Other days, and am filled with sadness;
In the old court were eight / Thousand ladies, and of them Gongsun
Led in the sword dance; / This fifty years have passed
Like the turning of a hand / And the old court has been
Submerged under the waves of war; / Pear garden dancers have vanished
Like the mist, and now but / The beauty of this one shines
In the chill sunlight; trees / By the imperial graves have
Grown high; grasses in this old city by the Qutang Gorge have faded;
Feasting, music and song have ended; / After pleasure comes the sadness
Of watching the moon in the east; Just an old man like me, not knowing
Where he goes, but simply pushing / Unwilling legs up lonely hills.[23]

In this cursive script, Wang Dongling contrasts large and small, long and short, square and round, and thick and thin. Emphasizing the application of ink, the fast tempo of his brush produces different levels of dry and moist ink. In creating an exciting expanding line, the large strokes represent not only different shapes but also various depths of the ink. The dry

CAT. 45

strokes evoke the traditional Chinese metaphor of the old tree and withered vines, while the "flying white," which is drawn with moist ink, recalls the autumn hill and light cloud. Wang Dongling prefers large images drawn in ink that spreads out and permeates the texture of absorbent paper. The original path of the brush, only slightly darker than the ink that has seeped into the paper around it, is scarcely visible, as the spread of moist ink expands the contours of the characters into new shapes. Usually, calligraphers express rhythm through broken strokes, by suspending lines rather than continuing them, in order to produce a sonorous and forceful effect. Wang Dongling has another way to convey rhythm, one that is neglected by many calligraphers: through the shape of characters themselves and especially through the generous application of ink, which contrasts with the simplified and continuous lines.

WANG XUEZHONG

Wang Xuezhong was born in 1925 in Shandong Province. He is currently a professor at Tianjin University and vice president of the Chinese Calligraphers' Association. A well-known calligrapher, painter, and poet, he has done much research in the theory of calligraphy and has published many volumes of his art and essays.[24]

46. HORSES AND WILLOWS, 1979

Ink and color on paper, 85.9 x 68.6 cm.
Seal: "Yebo"

The Year of Wuchen, Yebo

Having investigated the relation of calligraphy, philosophy, and religion, Wang Xuezhong has developed a theory of three approaches to calligraphy according to the three schools of philosophy: the Confucian, Buddhist, and Daoist. Confucian calligraphy started in the writing of the classics, and it thus created the standard characters needed for examinations and for practical purposes, neatly lettered and uniform. Buddhist calligraphy reflects Buddhist piety and passion, unrestricted by any practical purpose. Buddhists inscribed their calligraphy on mountain cliffs; the writing is powerful, sometimes wild, and has tremendous momentum. This type of calligraphy has long been excluded from the two schools of "bei" (referring to stele inscriptions) and "tie" (models for copying). Daoist calligraphy was often the product of artists who failed in their official careers and who therefore, seeking detachment from political and material life, indulged in metaphysical speculations. Daoist calligraphic style is marked by a lack of affectation and a touch of mysticism.[25]

Wang Xuezhong has consistently upheld the concept of the unity of form and content: "When a person writes, the natural feelings that spring from the rules of writing and the content of the text should be expressed to whatever extent is possible. That is my view of the unity of intention and image."[26] He believes that a true artist must not only discover himself but must also have the courage to surpass himself or even his times. Even if he fails, his work is still significant, because it shows the courage of the artist in constantly attempting innovations.

While he is constantly in the process of changing his artistic form, there is a relatively stable element in Wang Xuezhong's work: his brushwork. His lines dance. In moving from

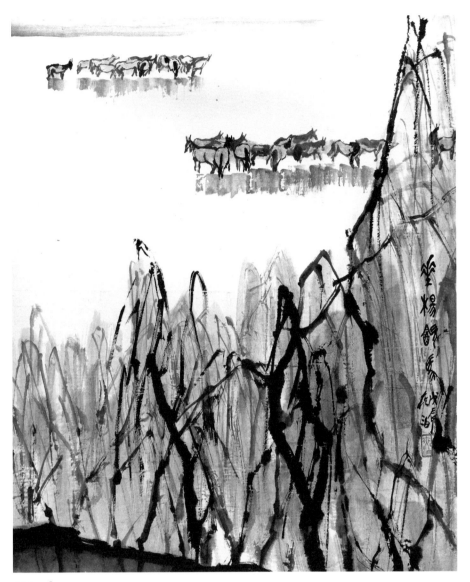

CAT. 46

stroke to stroke, he tends toward straight lines and sharp turns, seldom using round lines. Even in seal script, which is usually characterized by round lines, he makes sharp turns, as in the inscription on this work. In both the trunks of the willow trees (painted with thick ink) and the twigs done in hollow strokes (as if with a half-dry brush), straight strokes establish the basic pictorial theme, their jagged structure set against the softer motions of a lighter brush. The artist has caught a fleeting moment in life. A spring breeze is swaying the weeping willows, which flutter and dance in the immediate foreground. Beyond, two groups of horses are quietly grazing, separated by a wide space in which they seem suspended. This combination of distance and proximity, movement and stillness, yin and yang, operates with Wang Xuezhong's characteristic brushwork to charge the surface of this painting with a particularly expressive tension.

WANG YONG

Wang Yong was born in Beijing in 1948. During the political and cultural turmoil of the sixties, he was sent to work in the countryside of Inner Mongolia but never abandoned his practice of calligraphy. His experience during this period has strongly influenced his approach to life and his art. In 1979, he passed the national college entrance exam and enrolled in the graduate program of China's Central Institute of Fine Arts, where he now serves as a professor of calligraphy.

47. COUPLET, 1992

Ink on paper (semicursive script), 2 sheets, each 231.0 x 49.0 cm.
Seals: "The Seal of Wang Yong" and "Born in the Year of Wuzi"

An eight-word stele engraved by Han Yufu,
The people of the Six Dynasties surpass Shen Dongyang.

CAT. 47

Wang Yong is well known for his reproduction of ancient folk calligraphy, from which, he feels, there is much to learn. He opposes the orthodoxy that considers classic inscriptions as the standard of Chinese calligraphy, and his position has had a wide influence on contemporary Chinese calligraphers. Folk calligraphy refers to certain kinds of writing that are considered primitive, not fully evolved, uncultured, such as oracle bone script, big seal script, and Han Dynasty tablet inscriptions.[27] To Wang Yong, this supposed lack of culture is in fact a legitimate form of expression created by pure and simple artists, who, unfettered by the rules of any official "culture" and unhindered by any predetermined regulations, wrote simple strokes, composed nonstandardized characters, or engraved characters with rudimentary carving skills. In Wang Yong's eyes, this kind of calligraphy achieves a special beauty, one that is pure and straightforward, full of life and vigor. He further observes that the disorder and nonconformity expressed in folk calligraphy open up unlimited opportunities for artists of later generations in their artistic re-productions and re-creations.

In this work, Wang Yong challenges the traditional structure and composition of calligraphy. Each of his characters presents its own form. Within individual characters there is a counter-

point of weight, heavy stroke against light, and the relationship between characters further complicates the rhythm of contrast and balance. In this way Wang extends a new sophistication to the simple forms of folk calligraphy.

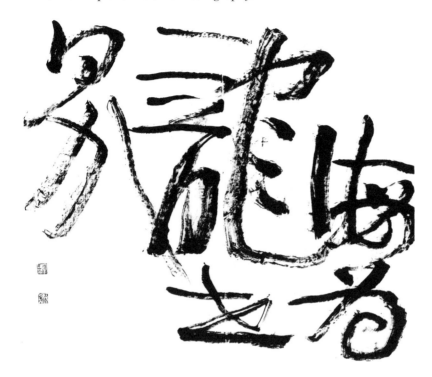

48. THE SEA IS THE DRAGON'S WORLD, 1996

Ink on paper (cursive script), 173.0 x 190.0 cm.
Seals: "Wang Is from Taiyuan" and "Sunset Studio"

The lessons of folk calligraphy are demonstrated in Wang's rough and brusque style. In particular, the outlines of his strokes have a tendency to be harsh and unrefined. Wang uses the base of his soft goat-hair brush, applies the brush to the paper at a slant, and produces varied dots, lumps, and surfaces. He often uses a small brush for large strokes and characters, pressing heavily on the tip of the brush and moving it rapidly on the paper. The quick rubbings with the base of the brush against the paper result in varied hollow strokes. A brush with sparse hairs usually produces traces of parallel black and white lines, while a brush with dense hairs usually produces traces of black dots or lumps. Written in this way, his characters often appear like abstract three-dimensional forms. Wang's means of expressing hollow strokes is unique, having no precedent in the history of calligraphy.

Space, too, plays an important expressive role in Wang Yong's work. The spatial structure of *The Sea Is the Dragon's World* is animated by the general tilt of the characters, from upper left to lower right. Within that dynamic diagonal movement, the brush creates a complex space of interpenetrating hollow strokes, with three-dimensional implications. The sheer momentum of the strokes, their extraordinary speed, adds particular force to the pressure of the large characters, which weigh heavily on the two smaller characters that bear their brunt at the bottom of the field.

49. POEM BY DU FU, 1990

Ink on paper (cursive script), 138.0 x 58.0 cm.
Seal: "Done by Wang Yong"

Once we traveled on the Yangtze and the Han;
Whenever we met we always parted drunk.
Then we parted like floating clouds;
Like flowing water ten years passed.
Now we laugh with joy as of old,
Our sparse temples flecked with gray.
Why not return once and for all?
There are green mountains by the Huai.[28]
— Yong

This work demonstrates Wang Yong's ability to portray the movement of time and the variety of space. Traditionally, calligraphers stop to recharge their brush with ink at the ends of phrases or sentences; they may decide to stop for ink when they want to emphasize something or when a certain verse comes to a pause. Wang will not redip his brush until the brush has fully exhausted its ink. He follows the brush's own call for ink. In Wang's view, what is important is the natural movement of the brush, which determines the rhythm of the calligrapher. According to Wang Yong, following the brush can liberate the calligrapher from conventional rules, enabling him to create new forms and new techniques.

Wang starts his first stroke with a fully loaded brush. Then he applies it to the paper with varying pressure, letting the brush produce a natural variety of strokes, alternately full or faint. In *huan*, the final word of the verse, the ink becomes exhausted in mid-character; and Wang stops to refill his brush before going on. The resulting internal contrast creates different degrees of brightness, a dimensional image with a varied sense of distance. The time of execution translates into a space of representation.

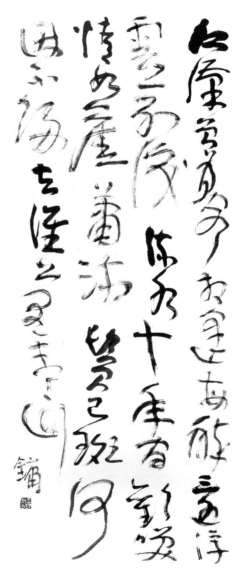

CAT. 49

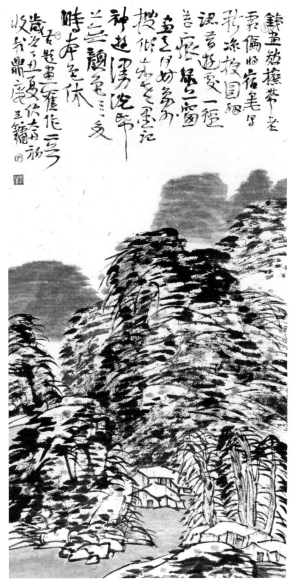

CAT. 50

50. LANDSCAPE, 1997

Ink and color on paper, 138.0 x 69.0 cm.
Seals: "Man of Jin," "WY," "Wang
Yong," and "Following the Meaning in
Landscape Painting"

An iron stroke scrapes, leaving a hard frost,
It's a new coolness sketched out with yesterday's ink.
I see the places I have been before in detail on the unfurled scroll,
Where a path of moss patches climbs to the window with green.

What need to grasp something to paint?
I'll just pour some old ink to record where my spirit goes.
Don't complain there's no color on this paper here,
For essence withers when color abounds.[29]

Above, I inscribe this painting with two old poems of mine. In the summer of
the year of Dingchou, on the top floor of the building, I paint just after a storm.
Wang Yong.

Artists have applied calligraphic methods to painting throughout history, and each believes he has his own individual way of combining the two. In this marriage of calligraphy and painting, however, Wang Yong does not follow the traditional sequence of painting outlines first, scraping strokes second, and finally washes. He avoids large blocks of ink or color, insisting that "too much color withers the essence." Instead, he builds form through the free movement of his brush, especially by applying the strokes of cursive script to an entire composition. He draws the banks of a brook, the trunks of pine trees, and the edges of hills with extended elastic curves, which are further interlaced or matched with throbbing dots. Rather than describing nature, these curves and lines are a direct or indirect application of calligraphic brushwork. The rapid motion of the brush, unconstrained by calligraphic structures, imbues the image with an overall vitality. "The seemingly casual, yet seemingly intentional connection between the strokes is an embodiment of the state of the total work and strengthens the force of the brush's direction and [the artist's] psychological inclination."[30]

Wang Yong's landscape paintings often depict the veins of mountains and stones or the ways certain trees or grass grow, without, however, being naturalistic illustrations. That Wang is particularly attracted to scenes of desolate autumn or forlorn winter relates to his philosophy of calligraphy. "What is the need to grasp for something to paint?" he asks. The meaning of the painting lies in the painting itself, an expression of the artist.

51. SEALS, 1995–96

Color on paper, 31.5 x 40.6 cm.

"The Thin Bird and Fat Flower," "Seal of the Chanting Jin Brick Studio";
"Wang, from Taiyuan," "Sunset Studio"

51.1 51.2

51.3 51.4

CAT. 51

Founders of two schools of seal cutting, Wang Yong and Han Tian-
heng are two of the best-known contemporary seal cutters in China.
Han in Shanghai and Wang in Beijing are known in seal-engraving
circles as "Han of the South and Wang of the North." As in his callig-
raphy, the lines of Wang Yong's seal cuttings are generally rough and
unrefined. Traditionally, seal cutters have engraved their images with
extreme care, precision, and delicacy. Wang Yong, however, chooses to
evoke a spirit of boldness and tries to unite both delicacy and ruggedness in his small engrav-
ings, creating on these small stones a sense of wide space.

FIG. 51A

FIG. 51A *Lou, by
Xu Shen (d. A.D.
120), from Shuowen*

In "The Thin Bird and Fat Flower" (*niao shou hua fei*) the word "bird" is tiny, whereas
the word "thin" is relatively large (CAT. 51.1). In the second line, the word "flower" is large,
and the word "fat" is small. The sharp contrast between the words on the left and right clev-
erly condenses the structure of the engraving, inviting the viewer to look deeper into the im-
plications of the verse. To the sides, the lines burst out of the seal as strong outward forces.

This feature of outwardly extended force also informs Wang's "Seal of the Chanting Jin
Brick Studio" (*jin zhuan yin shi yin*) (CAT. 51.2). The character in the upper right fuses with
the seal's edge; at the lower left, two more characters fuse with the edge in a similar way. At
the same time the edges of the seal on the upper left and lower right are open, and the charac-
ters there possess a centrifugal force.

Xi yang lou refers to the artist's studio, which is located on the top floor of a building
(CAT. 51.4). The light of the setting sun comes in through the window, which opens to the
west, hence the origin of the word for "west": xi *yang* means the setting sun. The character *xi*
is inscribed horizontally, overlapping one edge of the seal. The character *yang* is extended ver-
tically in running script instead of seal script; without a corresponding edge at the bottom, it is
tilted toward the lower right. In the third character, *lou*, the last stroke overlaps one edge of
the seal (cf. CAT. 51A). In this way, the inscription appears not only compact and elegant but
also open and expansive, unconfined by the limits of its small field.

In this extended space, Wang Yong's semicursive strokes remain coarse, natural, and full
of motion. Simple but strong, they reflect his studied exploration of the brushwork of folk cal-
ligraphy. Wang's strokes in semicursive script are more fully illustrated by the ways he treats
the edge of a seal: the continuous line is twisted left and right and the brush has replaced the
chisel (FIG. 51B). Wang Yong even tries to incorporate some of the features of calligraphy in
his seal cuttings; he uses his chisel to circle and correct a misinscription on the edge of the
seal, which is without precedent in the entire history of seal cutting.

FIG. 51B

FIG. 51B *Edge of
Seal (cat. 51)*

WANG YOUYI

Wang Youyi was born in 1949 in Pinggu, a suburb of Beijing. In 1987 he passed the national college entrance examination and was accepted as a student of calligraphy at the Capital Normal University. He has won several nationwide calligraphy titles and is now well established as a professional calligrapher. Presently, he serves on China's National Review Committee for works by young and middle-aged calligraphers.

CAT. 52

52. FOUR POEMS BY DING FUZHI, 1997

Ink on tan paper (seal script), 271.0 x 69.0 cm.
Seal: "Youyi"

Fifty years have not yet made me old.
In search of ways to craft my art, I've labored all these
days.
I'm fortunate to have such friends to give me timely aid,
Yet for inspiration I prefer the past masters.

With joy I welcome back the winter sun on its return;
Facing fading flowers, I will drink another round.
The wind and snow descend early on the farmer's fields,
Whether the coming harvest be rich or lean, it is impossi-
ble to say.

While traveling, I most enjoy a famous mountain view,
Though recently my feet get tired whenever I go out.
If I ask the ancients, they will be no help here:
My home has no porter, and the gate is closed.

Three days of constant rain arrive upon the eastern wind,
The water rises in the lake to the level of the plain.
This kind of wind, this kind of rain, are like ten thousand
horses' hooves.
The waters ripple and the moon is high.

Four poems by Ding Fuzhi [1878–1949]

Wang specializes in oracle bone script, also known as tortoise shell inscription (*jiagu wen*), believed to be the oldest written form of Chinese script. It was recognized as a special school in the field of calligraphy only in this century, when large numbers of inscribed tortoise shells were excavated. Although scholars, such as Luo Zhenyu (1866–1940), Dong Zuobin (1895–1963), and Guo Moruo (1892–1978), have appreciated this kind of calligraphy from an archaeological perspective, their own inscriptions tended to be direct imitations of ancient oracle bone scripts. Only during the past decade have certain calligraphers begun to explore oracle bone script creatively, and to gain recognition for specializing in this form of writing. Wang Youyi is one of these specialists.

Inscribing with a knife on hard bone or shell is totally different from writing with a brush on paper; the engraved lines tend to be straight, reflecting the physical difficulty of such engraving. Calligraphers writing in oracle bone script on paper often seek to create similar effects, with lines and strokes that are slim and straight, dynamic in their tension. In imitating oracle bone engraving, Wang Youyi varies the way he moves his brush, combining straight with curved. Each character appears in its own unique form, rendering the entire composition irregular and uneven. Yet by varying the movements of his brush, the weight of his lines and their direction, he establishes an overall rhythm that is particularly lively, even sprightly.

53. TWELVE ANIMALS, 1997
Ink on paper (oracle bone script), 103.8 x 69.0 cm.
Seal: "The Seal of Wang Youyi's Calligraphy"

Rat, Ox, Tiger, Rabbit, Dragon, Snake, Horse, Ram, Monkey, Chicken, Dog, and Pig.
In oracle bone script there is no pictograph for "rat"; therefore I selected a small seal script of a rat to compensate. Youyi.

CAT. 53

Wang Youyi differs from conventional oracle bone calligraphers in the way he applies his brush and ink, replacing sharp and hard lines with elastic curves (cf. FIG. 53A). Traditional oracle bone or seal script calligraphers use the center of the brush to construct lines of uniform width. Wang, however, uses the sides of his brush more often than the center, and the turns and twists create varied effects. He begins each character with a fully loaded brush, then works it until it is dry, when the character may taper off in "flying white."

FIG. 53A

54. COUPLET, 1995

Ink on paper (seal script), 2 sheets, each 261.0 x 51.5 cm.
Seal: "Youyi"

> *As one of the division's brigades turns home,*
> *The moon plays over three frontiers.*

The characters in this work were selected by Wang Youyi from the inscription on the bronze vessel known as San Shi Pan, dating from the Western Zhou Dynasty (13th–11th century B.C.). Written in big seal script, these characters are squarish in appearance with lines of uniform width. Characters sharing the same horizontal plane tend to be symmetrical in form, but each individual character tends to have a full and lively configuration of its own.

While Wang maintains the irregularity and variety of San Shi Pan, his characters are taller. *Shi* (division), at the top on the right, is composed of two halves: its left half tilts from upper left to lower right, while the right half tilts toward the lower left. The second character, *huan* (turn), is tilted slightly toward the lower left. The third character, *yi* (one), moves horizontally, and the character on the bottom, *lü* (brigade), extends toward the lower right. Wang's method of brush application is unique. Using homemade brushes consisting mainly of goat hairs mixed with wolf hairs and palm fiber, he twists the different sides of his brush in such a way that the resulting lines and strokes are exceptionally dynamic, vivid, and varied.

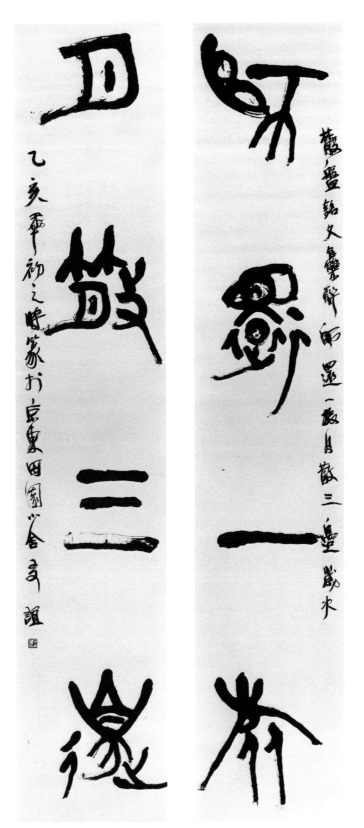

CAT. 54

ZHANG DAOXING

Zhang Daoxing was born in Hebei Province in 1935. He is a well-known calligrapher, a painter, and a seal cutter. His calligraphy and painting have won many prizes in nationwide exhibitions and competitions. He is a member of China's National Review Committee for painting and for calligraphy.

55. THE RIVER FAMILY, 1995

Ink and color on paper, 67.0 x 67.0 cm.
Seals: "The Seal of Zhang Daoxing" and "The Studio of Wengui"

In this work Zhang reinterprets traditional Chinese realistic painting style by using a traditional method (*se bu ai mo*), in which color does not overlap the inked lines. In his drawing, and in his ink-and-wash painting, Zhang distributes thick colors throughout the paper. The strong, thick, and condensed red, yellow, and blue patches are scattered symmetrically and represent a radical departure from traditional freehand brush painting, which is known for its light ink and color. Rather, the compositional structure derives from calligraphy with its contrasts of dry and moist. The subjective arrangement of color and abstract form gives the image a startling power. While one might at first assume the influence of Western Expressionism, bright reds, yellows, and blues, in fact, often appear in traditional Chinese folk paper-cuts (*jianzhi*). The distribution and molding of the color typical of paper-cuts is also reflected in his use of space. His love for folk art is manifested in the theme of the painting as well as in its execution.

CAT. 55

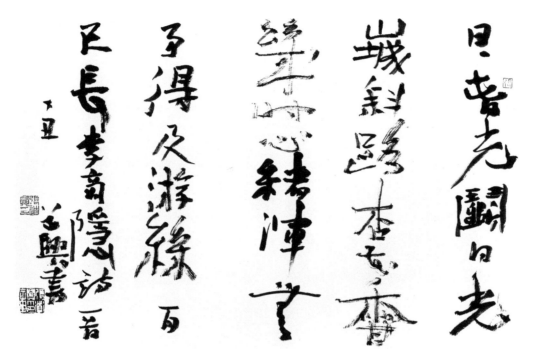

CAT. 56

56. DAILY, 1997

Ink on paper (semicursive), 45.0 x 67.0 cm.
Seals: "Zhang," "The Seal of Zhang Daoxing," and "Zhang Daoxing's Seal"

> *The relentless glow of spring battles with the sun's rays,*
> *And this steep road by a mountain town fills with the scent of almonds.*
> *How often my mind is completely without care,*
> *Like fluttering silk one hundred feet long.*
> —Li Shangyin

Zhang Daoxing's use of space, although influenced by folk art, is principally an extension of the tenets of calligraphy. The first column is written with thick ink, but the second is done with a dry brush; and the upper half of the third column also displays dry brushwork, before abruptly shifting back in the lower half to solid ink. The last three lines are all written with uniformly heavy ink. Zhang's distribution of inking on the surface—dry or moist, heavy or light—creates an overall composition that assumes an almost pictorial quality in its spatial implications.

57. WEIGHING FISH, 1995

Ink and color on paper, 40.0 cm. diameter
Seals: "The Seal of Zhang Daoxing" and "Zhang"

FIG. 57A

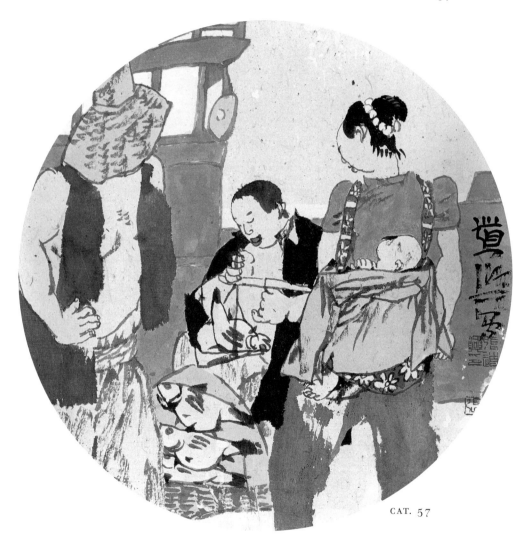

CAT. 57

Consciously introducing calligraphy into painting is a common method that has been prac-
ticed by generations of artists. As early as the ninth century, Zhang Yanyuan wrote that callig-
raphy and painting came from the same source; and this point was again emphasized by Zhao
Mengfu in the Yuan Dynasty:

When painting bamboo, one should master the eight methods
[of drawing the character *yong*].
Those who understand this principle thoroughly
Will recognize that calligraphy and painting have always been one.[31]

Why the brush technique of calligraphy has been incorporated into painting lacks an easy explanation.[32] Zhang Daoxing, however, offers one suggestion: "The line in Chinese art has the function of representing objects and also exists as an entity which does not represent form. The brush technique can decide the appearance of the line and establish the characteristics of the form, and the characteristics of the form can lead to the whole style of the painting."[33]

The inscription of *Weighing Fish* is mainly squared, a direct result of the artist's study of Northern Wei stele inscriptions, in which angular shapes predominate (FIG. 57A). Although he signed the painting in cursive script, here too he has abandoned the curved lines normally used in this script type. Similar brushwork appears in the lines defining the mother's sling. The dry ink, suggestive of "flying white," is here exploited for its representational effect, allowing line to fuse with the form it defines.

58. FROM *DAO DE JING*, 1995

Ink on paper (running script), 30.0 x 64.0 cm.
Seals: "The Seal of Daoxing" and "Zhang"

> *Complete perfection seems flawed,*
> *But its use can never be exhausted;*
> *The fullest seems empty,*
> *But its use can never come to an end;*
> *The straightest seems bent;*
> *The most eloquent seems mute;*
> *The most skillful seems clumsy.*
> *Movement overcomes cold;*
> *Quiet overcomes heat.*
> *So inaction and quiet help one*
> *Become a leader of the world.*[34]
> —Lao Zi (ca. 571–471 B.C.)

In this work Zhang Daoxing explores a new approach in the application of ink. By adding a little mica to the ink, he makes it seem to sparkle, enhancing the quality of the line. The mica also makes the ink thicker and stickier, radically altering the traditional relation between ink and brush. The thicker ink mixture slows down the process of writing and produces an unusual visual effect: the hollow stroke is exceptionally coarse; it looks like paint rather than ink. In addition, when a full brush is first applied to the paper, the edge of the stroke is darker than the inner part. Since the mica collects in the center of the brushstroke, parts of certain characters appear in an unusual black-and-white outline. This effect is perhaps the most outstanding feature of Zhang's novel style.

Experimental techniques of applying ink have been popular throughout Chinese art. During the Ming and Qing Dynasties, for instance, artists classified ink into different grades of darkness and density and could choose inks to suit particular expressions. Zhang Daoxing, however, has taken this practice one step further with his wholly new recipe for the ink itself.

CAT. 58

59. SU SHI'S WORDS, 1990

Ink and color on paper, 34.0 x 34.0 cm.
Seals: "Ten Thousand Ways Is Actually One," "Zhang," "Wengui Studio," "The Seal of Daoxing," "Zhang," "Jian Garden," "The Seal of Zhang Daoxing," and "The Seal of Zhang Daoxing"

> *Once there were three old people meeting, asking about each other's ages. One person said: "I cannot calculate my age, but I remember when I was young I had connections with the creator of heaven and earth." Another person said: "The day the earth rose from the sea, I started accumulating chips, and now there are enough to fill three rooms." The third person said: "All the peaches I have eaten, I have thrown their pits at the bottom of Kunlun Mountain, and now that pile is as tall as Kunlun Mountain." As far as I am concerned, these three old men are no more different than microscopic particles. Dongpo's* [Su Shi's] *words.*

In this exuberant combination of painting and calligraphy, the three boasting old men are given different emotions. The two figures on the left , one dark and one lighter, observe the third old man at the right, who, with an exaggerated gesture, seems to be ranting. The patterned surface of the ground resembles the ancient, sagely earth to which the old man is comparing himself. Filling the background are eleven columns of calligraphy. The spaces devoted to painting and calligraphy are almost equal. Zhang's unique semicursive is written in short, unconnected strokes, with sharp turns and a strong verticality. The old men's clothing and facial hair are executed in cursive, while darker lines are written in a seal script technique. Their eyes, eyebrows, and hands are rendered in the same short strokes that accentuate the calligraphy. The overall effect is a merging of figures and calligraphy, as the three old men seem to fall naturally within the columns of characters and, indeed, to be read from right to left.

CAT. 59

ZHANG QIANG

Zhang Qiang was born in Shandong Province in 1962. Currently an associate professor in the art department of Shandong Art Institute, he is an active advocate and practitioner of modern calligraphy theory and has coordinated and participated in many modern calligraphy exhibitions. His publications include *Studies on Chinese Painting, Broken Cubes in Games: Postmodernism and Contemporary Calligraphy* and *A Comprehensive Review of Modern Calligraphy*.[35]

60. A–B MODEL 18, NO. 6, 1996

Ink on paper, 180.0 x 96.0 cm.
Seal: "The Report of Zhang Qiang's Study of the Trace"

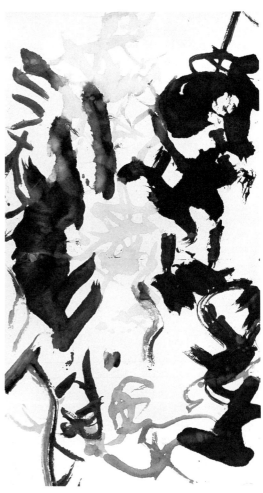

CAT. 60

More than any other calligrapher in China today, Zhang Qiang has set out to transform the art in radical ways. His notion of modern calligraphy challenges traditional assumptions—and may even undermine the entire history of calligraphy—by stressing the interaction of two agents, and the creative process itself, rather than the final product. Acknowledging the role of the paper support, he has assigned to it an active part in the creative process. If the brush is creative agent A, a masculine force, then paper, for Zhang, is creative element B, and feminine. To put this aesthetic theory into practice, he has a female companion control the paper as he works, moving it according to her own inclination and feeling. The interrupted gestures and broken lines that result represent a synthesis of the creative urges of A plus B, of male and female, a record of their reciprocal traces. Zhang has termed this creative method of calligraphy "traceology."[36]

Zhang's notion of the male brush and the female paper was inspired by feminist theory. In his A-B Model series, the woman becomes the dominant agent in the creative process, assuming final control of the work—even to requesting the addition of new materials, such as milk. Thus far, Zhang has collaborated with twenty-six female artists; he plans eventually to work with one hundred, of various ages and occupations. The entire project, called *The Trace of A and B*, is expected to be completed by the year 2000.

Zhou Huijun was born in Zhejiang in 1939. She is now a professor at Shanghai Institute of Chinese Painting and is regarded as an outstanding modern calligrapher. Zhou's first work, *Lu Xun's Selected Poems*, was published during this period. Of it the scholar Shen Peifang remarked, "The poem vividly reflects people's grief, depression, and discontent of the time."[37] In her statement for this exhibition, Zhou hinted at the evolution of her artistic ideas: "When I was young, I became seriously ill. This misfortune gave me a determination not to yield to fate. I attempt to write with a strong and heroic yet natural style, as if to declare that I was broken in health but not in spirit."

61. ALWAYS HAVE INTERNAL GOODNESS; DARE NOT TO BE EVIL, 1994

Ink on green paper (semicursive script), 130.0 x 32.5 cm. Seals: "The Painting of Heart" and "Zhou Huijun"

Three characters—*qi, xie,* and *gan* (goodness, evil, doing)—establish the vertical spine of the column by their greater size, density, and thickness of line. Between these markers, the smaller characters create a series of tighter, more concentrated units. The full sequence, then, finds a dynamic rhythm that controls the gravitational fall of this strong statement.

CAT. 61

CAT. 62

62. HANGING SCROLL, 1994

Ink on gray paper (running script), 64.0 x 61.5 cm.
Seals: "The Painting of Heart," "Zhou Huijun," and Bird (image)

> *How the freshness and fragrance gather and embellish the halberd!*
> *Lightly, the colored skirt floats like a tiny boat.*
> *—The year of Jiaxu, Zhou Huijun.*

There is a striking contrast between the size of the characters and thickness of the strokes. The first character, *po* (how), is completed in almost one stroke: the left part is thick and dense, with the lines gradually becoming lighter until the last dot is separated from the upper part and linked to the character below, *you* (have), which is shifted to the right. The transition is ingeniously smooth. The third character, *qing* (fresh), also off center, is thick and varied in tone. The fourth, *xiang* (fragrant), returns to the middle of the column. At the core of the work, the energy of the brush reaches a climax in the largest character, *ji* (halberd), its lines forming a strong internal rhythmic structure. From that solidity the brush moves to an almost giddy lightness of circling movement. The shifting tone of Zhou's calligraphy suggests intense changes of mood during the course of writing.

Ink on paper (semicursive script), 2 sheets, each 136.0 x 23.0 cm.
Seals: "Huijun" and Bird (image)

> *Noble prose, prolific, can improve the common lot.*
> *Fine discourse, on the tongue, is a benevolent chorus.*

Compared with her preceding works, this scroll by Zhou Huijun seems an expression of relative tranquillity and restraint. Although the size of characters and the thickness of strokes vary, the contrasts are less abrupt than in the previous two pieces. The progression of lines is relatively smooth and steady. In the first character, for instance, they are thick; the second character is smaller, the third extends, the fourth is restrained. The sixth character is thick, and the seventh is similar to the second and the fourth. This smooth modulation reinforces the meaning of the couplet and accords with Confucian ideology that diction should be moderate.

CAT. 63

64. THE HUMBLE HOUSE, 1997

Ink on tan paper (standard script), 67.0 x 51.0 cm.
Seals: "Huijun" and "Painting of Heart"

Know the mountain not by its height;
 its spirit gives the peak its name.
A river is not known by its depth but by the
 Dragon's life within.
My house is just a humble place, yet it exudes
 a noble air.
The growing moss perfumes the steps through my
 window screen.
Chatting pleasantly with a grand scholar, I have
 no dealings with the vulgar herd.
Here is where we pluck the fine zither and read
 the classic tomes;
Never are our ears attacked by wailing flutes;
Our eyes are never dulled by the official's scrawl.
Nearby is found the home of Zhuge
As well as the dwelling place of Ziyun.
Confucius said it best: "How humble is this place."
—Liu Yuxi (A.D. 772–842)

FIG. 64A

FIG. 64B

Traditionally, regular script has been likened to standing, running script to walking, and cursive to running. Regular script is the basis of running and cursive, while running script and cursive are an extension and exaggeration of regular script. Liu Xizai (1799–1870), a calligrapher of the Qing Dynasty, affirmed the essential interdependence of brushwork among three scripts: "Without using the brushwork of running and cursive scripts (*xingcao*), the strokes of standard will not be interrelated with each other. Without the application of standard script methods, then running and cursive scripts will not have a foundation."[38] Liu's analysis is a key to understanding standard script.

Zhou's structure and brushwork demonstrate her understanding of this mutual dependence. She transforms the upright and square structure of regular script into an uneven shape, giving it the active flexibility of cursive. The undulating movement of the lines recalls the calligraphy of Chu Suiliang (A.D. 596–654) (FIG. 64A), but Zhou's open and final strokes have the squareness characteristic of Northern Wei stelae (FIG. 64B). The marked variation of speed and thickness, along with the occasional appearance of "flying whites," results from her alternation between cursive writing and regular script. Calligraphers in the past, such as Zhang Ruitu (1570–1641) and Huang Daozhou (1585–1646), successfully brought cursive methods to the writing of regular script. Zhou not only follows their lead but also combines their techniques with different styles, uniting steady brushwork with free structure. By combining different historical styles, she creatively produces elegant new effects.

山不在高，有僊則名，水不在深，有龍則靈。斯是陋室，惟吾德馨。苔痕上階綠，草色入簾青。談笑有鴻儒，往來無白丁。可以調素琴，閱金經。無絲竹之亂耳，無案牘之勞形。南陽諸葛廬，西蜀子雲亭。孔子云：何陋之有。

右錄劉賓客陋室銘 乙酉夏內趙彥作于安慶

CAT. 64

1. Bai Di discusses his work in "Jibengong Yu Chuangzaoli," *Shufa Daobao* (6 and 13 November 1996).

2. "Jibengong Yu Chuangzaoli," *Shufa Daobao* (13 November 1996).

3. See Wu Lipu's review, "Exhibition of Chinese Paintings By Han Tianheng," *Evergreen Art News* (12 December 1995).

4. *Hanyu Da Cidian*, vol. 8 (Shanghai, 1986) 193.

5. For further discussion of He Yinghui's space, see Wei Tianchi, "He Yinghui Shufa Yishu Zhi Wojian," *Zhongguo Shufa* (1986, no. 1):42.

6. "Head of silkworm and tail of swallow" is a traditional metaphor for the ornamental beginnings and ends of strokes. It is one of the characteristics of clerical script and of Yan Zhenqing's standard script. Mi Fu (1051–1107) criticized Yan's calligraphy for this reason. See his "Haiyue Mingyan," *Lidai Shufa Lunwen Xuan*, vol. 2 (Shanghai, 1979) 361.

7. Translated by Burton Watson, *The Old Man Who Does as He Pleases: Selection from the Poetry and Prose of Lu Yu (You)* (New York, 1973) 3.

8. Translated by Alex Beels.

9. Translated by James Legge, *The Book of Poetry* (New York, 1967) 62.

10. Translated by Yang Hsien-yi and Gladys Yang, *Li Sao and Other Poems of Chü Yüan* (Beijing, 1953) 9.

11. On Liu Wenhua's calligraphic technique, see Zhang Rongqing, "Liu Wenhua De Shufa Shijie," *Zhongguo Shufa* (1992, no. 4):20–21.

12. Translated by Xu Yuanzhong, *Li Shangyin Xuan Ji*, ed. by Zhou Zhenfu (Shanghai, 1986) 294.

13. The general characteristics of Zhangcao brushwork are a larger right "foot" and a flat square shape. Also, the characters are isolated from each other.

14. Wang Xing, "Zhonguo Shufa Zhuyi Zaishu," *Shufa Zhuyi Wenben* (Guangxi, 1997) 241.

15. See the interpretation of Li Shilao, "Shao Yan Shufa Zhuangzuo Zuotanhui Fayan Xuandeng," *Zhongguo Shufa* (1993, no. 3):49.

16. Zhang Qiang, *Youxi Zhong Posui De Fangkuai: Hou Xiandai Zhuyi Yu Dangdai Shufa* (Beijing, 1996) 264.

17. Translated by Xu Yuanzhong, *Li Shangyin Xuanji*, ed. by Zhou Zhenfu (Shanghai, 1986) 14–15.

18. Sun Boxiang, "Shipinggong," in *Zhonguo Shufa Da Cidian* (Beijing, 1989) 210.

19. Wang Xizhi, "Ti Wei Furen Bizhentu," in *Lidai Shufa Lunwen Xuan*, vol. 1 (Shanghai, 1979) 27.

20. See introduction, note 19.

21. Translated by James Robert Hightower, *The Poetry of T'ao Ch'ien* (London, 1970) 11–12.

22. Translated by Chou Hsiang-kuang, *A History of Chinese Buddhism* (Allahabad, 1956) 138.

23. Translated by Rewi Alley, *Tu Fu: Selected Poems* (Beijing, 1962) 164–66.

24. Wang Xuezhong's recent books are *Mohai Siji* (Shandong, 1993) and *Gui Mian Ji* (Chongqing, 1992). For a study of Wang's art, see the collected essays edited by Liu Zongwu, *Wang Xuezhong Yishu Guoji Yantaohui Lunwenji* (Tianjin, 1993).

25. Zhang Yiguo, "Wang Xuezhong De Yixiang Tongyi Guan," in *Wang Xuezhong Yishu Guoji Yantao Hui Lunwenji,* 158.

26. Wang Yuchi, "Wang Xuezhong De Shufa Lilun He Shufa Chuangzuo Chengjiu," in *Wang Xuezhong Yishu Guoji Yantaohui Lunwenji,* 166.

27. For further discussion, see Chen Xinya, "Wang Yong Shuyi De Gouchen Ji Biyu Jiexi," *Wang Yong Shufa Ji* (Beijing, 1992) 1–3.

28. Translated by Alex Beels.

29. Translated by Alex Beels.

30. Xue Yongnian, "Neng Cong Puye Jian Zhenqing: Du Wang Yong De Shanshui Hua," *Ying Chunhua* (1991, no. 1):15.

31. English translation in Wen Fong et al., *Images of the Mind,* exh. cat., Art Museum, Princeton University, 1984, 104.

32. Jin Xiucai has an excellent discussion on literati painting. He believes, however, that Yuan painters were interested in the practical issues in painting rather than the theory. For more information on this issue, see his "Lun Wenrenhua," *Duo Yun* 12 (January 1987):106–18.

33. See Zhang Daoxing, "Bimo, Chengshi, Chuangxin," *Meishu* (1995, no. 2):84.

34. Translated by Gu Zhengkun, *Lao Tzu: The Book of Tap and Teh* (Beijing, 1995) 196–97.

35. *Youxi Zhong Posui De Fangkuai: Hou Xiandai Zhuyi Yu Dangdai Shufa* (Beijing, 1996); *Xiandai Shufaxue Zonglun* (Shandong, 1993).

36. See Zhang Qiang (Yuan Qi), "Zhang Qiang Zongjixue Baogao De Qiepian Zijian," on an exhibition poster entitiled Zhang Qiang Zongjixue Baogao.

37. Shen Peifang, "Gusheng Zhishu: Zhou Huijun Yu Tade Shufa Yishu," *Zhongguo Shufa* (1996, no. 4):16.

38. Liu Xizai, "Yi Gai," *Lidai Shufa Lunwen Xuan,* vol. 2 (Shanghai, 1979) 679.

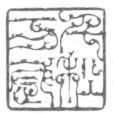
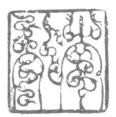

PLATE 1 Han Tianheng,
Seals (details, CAT. 5)

PLATE 2 Wang Yong, *Seals*
(CAT. 51)

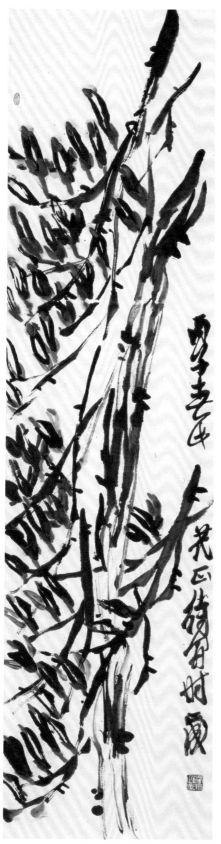

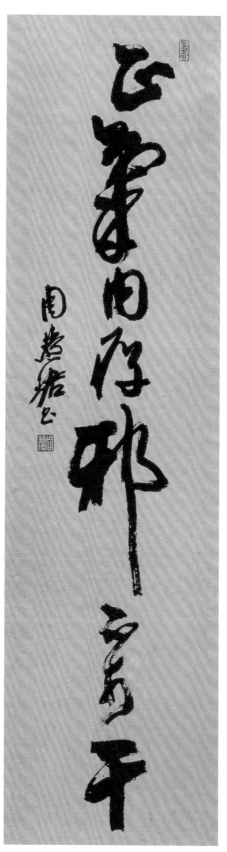

PLATE 3 Liu Zhengcheng, *Magnolias* (CAT. 21)

PLATE 4 Zhou Huijun, *Always Have Internal Goodness; Dare Not To Be Evil* (CAT. 61)

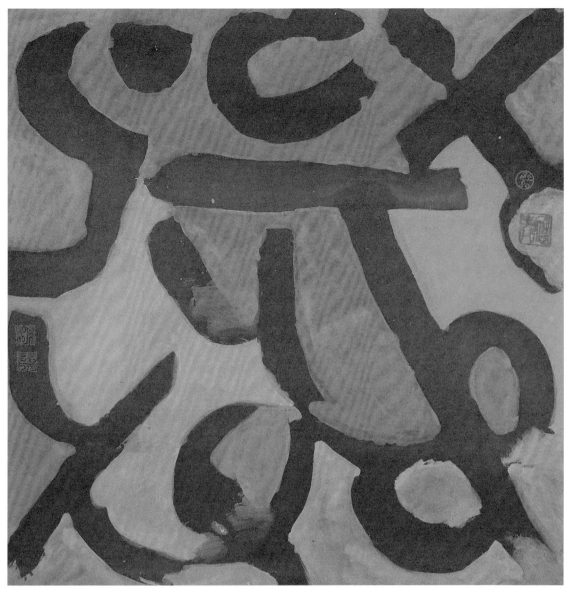

PLATE 5 Luo Qi, *The Original Word* (CAT. 24)

PLATE 6 Sun Boxiang, *Poems on an Inscription by Hong Ren* (CAT. 37)

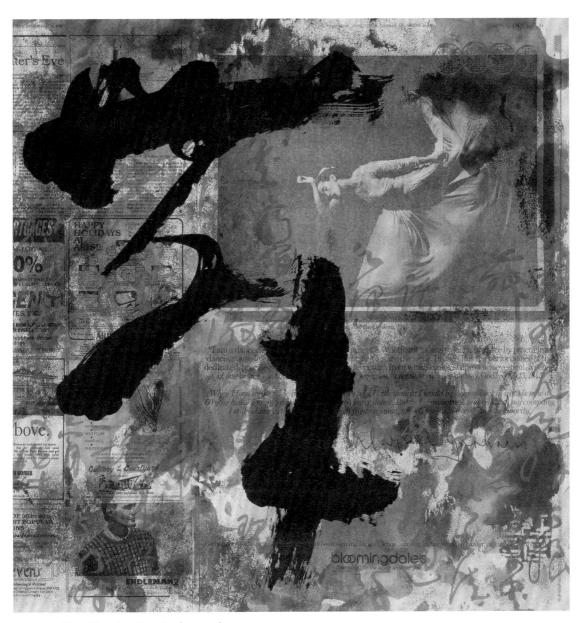

PLATE 7 Wang Dongling, *Dancing* (CAT. 44)

PLATE 8 Wang Xuezhong, *Horses and Willows* (CAT. 46)

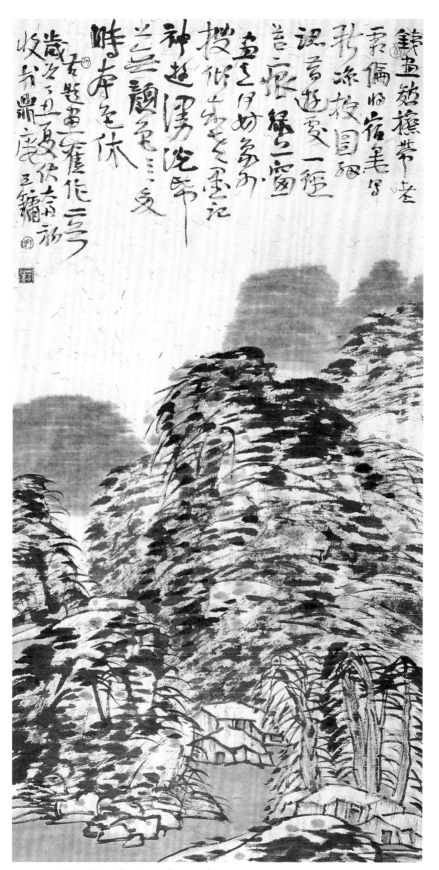

PLATE 9 Wang Yong, *Landscape* (CAT. 50)

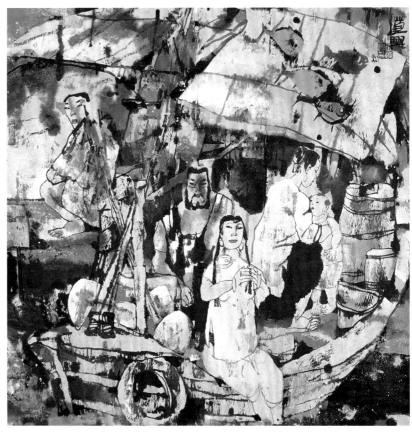

PLATE 10 Zhang Daoxing, *The River Family* (CAT. 55)

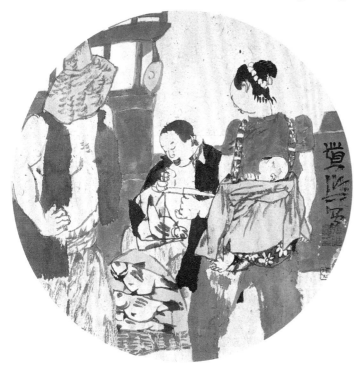

PLATE 11 Zhang Daoxing, *Weighing Fish* (CAT. 57)

BRICE MARDEN AND CHINESE CALLIGRAPHY: AN INTERVIEW

Brice Marden, *Epitaph Painting 2*, 1996–97, oil on linen, 94 x 93½". Private collection

BRICE MARDEN AND CHINESE CALLIGRAPHY: AN INTERVIEW

This interview with the contemporary American painter Brice Marden took place in New York City on 14 October 1997.

YZ: What is it that appeals to you about Chinese calligraphy?

BM: What initially appealed to me was the quality of the drawing, just looking at them as drawings. There was no understanding of the characters, what the characters said. It was initially the energy that was transmitted through the drawing. There is no form in Western art that is the same, or does the same. So it became, in my own study of art, a unique form that I felt engendered closer inspection.

YZ: How were you introduced to Chinese calligraphy?

BM: My first great experience with it was an exhibition at the Japan House called *Masters of Japanese Calligraphy, 8th through 19th Century*. I forget the dates of the show—I have the catalogue here. That was Japanese calligraphy, but then I became more interested in Chinese calligraphy because it seemed to be less elegant. The Japanese forms seemed too elegant.

YZ: Could you tell me about your collection of Chinese art?

BM: I have one piece of calligraphy by Wang Duo and a number of objects—a neolithic blade, some jade bi, some Song and Tang teacups. I'm not going at it with any kind of collector's structure in mind, but if something comes up that I like and I can afford, I tend to get it.

YZ: What appealed to you about Wang Duo?

BM: Well, the piece I have I bought completely on my own and with no advice. What appealed to me about it is that it is a working piece; he has things circled and corrected and changed. It is a rough draft, and that seemed to be somewhat parallel with my own way of working. I'll start and make corrections, and just keep correcting and correcting until I really can find nothing left to correct. I had no idea who Wang Duo

was, and I really had not given much thought to his specific quality of line or anything like that.

YZ: Some American artists such as Kline and Motherwell were interested in Asian calligraphy. Is there a modern artist who is inspirational to you in this way?

BM: Not really. Kline was very defensive, and he would have denied any influence from calligraphy. You're often forced into certain situations because there is this tendency to oversimplification on the parts of some observers. He was probably denying it, so his work would be seen for other things that he felt were more important. I was very much influenced by Kline when I was younger, and it was part of a natural evolution that had a lot to do with drawing—fast drawing—coming up from Velázquez and Goya and Manet to Kline. These were all people who drew very fast, which can be the case in calligraphy, although I find that it doesn't tend to be as fast as one thinks it is. It's very careful, no matter how fast it gets done. Mark Tobey was another artist very much influenced by calligraphy and also very much influenced by Asian philosophy. He spent time in a Zen monastery, but I'm not really influenced by his work. But I am very much influenced by that same kind of thought. I'm investigating principles of Chinese painting and various Daoist principles that get applied to the picture. It's all part of a continuing search on my part for an expansion of certain principles that I believe can be inherent in painting—spiritual, mystical. I really believe that these can be transmitted through art. This does not mean that I am a spiritual or mystical person, although I'm more that than a formalist. I tend to be more romantic than anything else.

YZ: You like to draw with sticks, standing far away from the paper. Why is that?

BM: As opposed to calligraphy, my work is usually not flat on the table; it's standing up, as you would work a canvas. My canvases are done leaning against the wall, and my drawings tend to be done that way too. I use long sticks because they tend to magnify gesture, so if you turn your wrist, it really shows up by using this longer stick. It also brings a certain kind of concentration because there's a lot of accident happening and it's very difficult to control. So you have this concentration that comes about by trying to maintain control and also trying to control the situation that arises when an accident occurs. I like this mixture of control/noncontrol, noncontrol/control. So, that's why I use the sticks. Also I like the idea of being farther away from the paper because I get to see what I'm doing, and I can have a better focus on the complete rectangle that I'm working on. If you're working closer, you tend to follow just the line that you are making rather than the whole drawing.

YZ: Can you talk about your feeling for the brush, the nature of brushes you prefer,

the way in which you hold the brush, and the way in which you approach the surface? What about the size of the field? The liquidity of your medium?

BM: I don't use a brush in my drawings; I use sticks. Sometimes I'll start a drawing in a very rough manner, and afterward I go in and make corrections. When I'm making the corrections, I'll draw with a black or dark-colored ink and make corrections with white and cancel out the dark lines. Or when I have enough cancellations, I'll start turning the cancellations into another image, which works in relation to the black drawn image. I use brushes when I paint, long-handled brushes. The brush is much more controlled because the bristles hold the paint in the proper way. With the stick, each stick holds it differently, so you have to make those adjustments. With the brush, it is very predictable. When I start a painting, it is very spontaneous. And when I use a long brush, held at arm's length from my body, my body tends to become incorporated into the drawing that goes onto the painting. That's why I use the long brushes. My paintings tend to be human-sized, or aspects of the painting will be human-sized if it's a much larger painting. As for the liquidity of the medium, when I start out I extend a lot, and accidents happen. It's the same in the drawing, but it's a little bit more controlled in the painting. I do a lot of drawing, working ideas up to the point where I want to translate them into painting. We can talk about this technically as well as culturally. Culturally, I feel this is very much related to and comes out of Abstract Expressionist painting. The size tends to be that size, the size that they used. There is this human size, which is a very de Kooning thing, Kline also, although Kline tended to paint more of a landscape kind of situation. I basically paint figures or landscapes. If it's not loosely based on a figure or landscape, it becomes a much more formal situation.

YZ: Some lines in your series of drawings Summer Group Extension are executed through dry strokes. Could you talk about your brushwork a little?

BM: What is it called in calligraphy, "flying whites"? I'm not working in imitation of the "flying whites." Yve-Alain Bois said that my "flying whites" were bad.

YZ: No, they're very good. It's not a Chinese line. It can be appreciated by everybody.

BM: I'm very much in tune with the surface of painting and drawing. I consider the surface in relation to the image to be a very complex and finely wrought—I want to say—"situation." It has a lot to do with modernity, about the plane and the relation of the image to the plane and how you keep the image attached to the plane, literally and visually. A lot of that has to do with how you manipulate the surface. So I'm very conscious of the surface, and my paintings tend to be made with paint that's very thin. I thin it out a lot with mineral spirits, and they tend to build up after I have the drawing mostly resolved. And then I'm approaching color decisions more carefully, and as I

do that I have to make finer adjustments; I have to put more and more layers on, so the paint tends to build up. Sometimes it doesn't. I've just finished a painting where the paint is very thin; the canvas texture shows through almost to a disturbing point, but I like the kind of roughness of it, so I'm going to leave it. I'm very conscious of the relation of the image to the surface, and I don't mistake the surface for the plane—I think they're distinct from each other. About the dry brushstrokes, I was looking at some of my older paintings this summer, paintings that were maybe about six years old, and I was surprised at how much dry brushwork there was. Now, my edges seem to be much harder.

YZ: I saw your dry brushwork. It's very difficult to make such a dry stroke, very difficult.

BM: Well, maybe. I don't seem to be having too much trouble with it.

YZ: In the spring, you exhibited two works that were inspired by Tang calligraphy. Could you talk about that?

BM: We had these Tang Dynasty epitaphs. A friend of mine who is a dealer in London had them, and he wanted to exhibit them. I suggested that I use them as a starting point for paintings, and we exhibit them together. I had never done anything like this before, but I actually made literal copies of the calligraphy. Not the actual calligraphy because these were carvings in stone, but of the characters. I did some preparatory drawings, I made a larger drawing, and then I translated that drawing, taken directly from the characters, onto the painting. I used that as my starting point. What I tend to do is to see what's there and what things want to go together. I used that as the beginning, and by intuitively following certain things that I think are suggested, an image starts to emerge. That's what happened; that's how I worked these paintings. There was really no connection with what was said in the epitaphs. One tended to be, it seemed to me, more masculine, and one tended to be more feminine: it was a male and female. But that just happened; I didn't concentrate on that. It was almost a formal problem. It's an appropriation—taking that given situation and turning it into a completely different situation, which resolves itself, or I resolve, or I am the medium toward its resolution.

YZ: In which direction do you expect to move?

BM: I've already started a group of paintings that are based on Western Han dancing figures. I have a lot of books in the studio—a lot of my images have to do with physical movement that can be related to dance. Reading the stories of Chinese dance where there's this ribbon dance, the long sleeves becoming an extension of the body. That fascinates me. I've done this painting called *Chinese Dancing*. That's what I'm

working on. I have three more paintings I want to do based on epitaphs, but I haven't started them yet. While this is all very much influenced by Chinese painting, calligraphy, ideas, also the stones, I'm working on this whole group of etchings that I started after I visited Suzhou and was looking at the garden stones. What really interests me is energy. I still adhere to this definition of a work of art as a constantly renewable source of energy. When anyone looks at it and begins to comprehend it, they're energized. I'm just quite interested in the way that the calligraphers and the painters really concentrated on ideas about transferals of energy or depictions of energy. They didn't depict it, but it's there. It's a very important part. There was a Mexican writer, Carlos Castaneda, who wrote about the shamans in Mexico and various objects that they would use in their ceremonies. Someone talked about Castaneda visiting his collection; and he would touch a piece and say, "it is working," touch another piece and say, "it's not working." He could feel the energy coming off. I believe in these kinds of things. I can walk through a museum and look at paintings that to me have no energy. I am much more interested in the things that seem to be transmitting energy. It's like the Astor Court in the Metropolitan Museum; it doesn't have the energy emanating from it that emanates from, say, a similar situation in Suzhou. Also, you go to the Lion's Grove Garden in Suzhou, and you can see that many of the stones were damaged and repaired, and the energy is impaired; it isn't working. But then when you see a great stone, it's like seeing a great piece of sculpture, or seeing a great painting, or seeing a great dance, or listening to a great piece of music: there's energy. I think this is really important. What do you have to do to yourself to be able to incorporate this into a picture? How do you transmit what you've done to yourself? It's like having the Qi come up through your body and translated onto the paper. This is the big influence. It wasn't the primary influence, but it's what it has become. What particularly interests me about Chinese art is the transmission of energy. But then it also points out how similar all art is. A Velázquez transmits this kind of energy just the way a Wang Duo does.

As I said, I'm really influenced by the Abstract Expressionists and by certain drawing qualities. A lot of the Abstract Expressionists' work was gestural, so you had the energy of the gesture. I don't tend to use that so much, or I slow it down. My paintings tend to be slow. They have an impact but it takes a while for it to become apparent. Instead of being hit with a C-major chord, you're hit with a hum, and it's a quiet hum that builds and generates its own symphonic quality, as a chord can. But it's a slower thing. I don't aim for impact. I aim more for a kind of resolution. I'm dealing with more formal problems: the rectangle, the shape of the paper, the shape of the canvas. How does the image relate to that, how does it hold to that? These for me are very important. In the beginning, I was using the idea of writing characters in columns, and

you saw it here, and here, and especially in the Cold Mountain paintings. It really was more like a grid, although it allowed me much more spontaneity and a kind of open gesture and much freer choice than I had been allowed or allowed myself in my paintings before that. That's quieted down a bit. My images are a little bit more under control. The Cold Mountain paintings were about resolving the paintings I had been doing for five years before that, which I think needed a closer inspection and push toward a resolution. That opened up other questions, and that's why I did six paintings based on the same ideas, but each painting is basically very different.

ARTISTS AND TEXTS

白砥

　　白砥1965年生於浙江省紹興市，是此次展覽中最年輕的一位書法家，在中國美術學院也是第一位從事書法研究的博士生。作爲新一代的書法家，他曾多次獲獎，其中包括第六屆(1995)和第七屆(1997)全國中青年書法展覽的獎勵。

1. 沙揚那拉，1994
墨色紙本（行草書），37.3 x 239.5厘米。
印：山陰白砥

　　　　最是那一低頭的溫柔，
　　　　象一朵水蓮花，
　　　　不傷涼風的嬌羞。
　　　　道一聲珍重，
　　　　道一聲珍重。
　　　　那一聲珍重裏有甜蜜的憂愁，
　　　　沙揚那拉！

　　　　徐志摩[1896–1931]詩一首，白砥

2. 凝固的時空，1991
墨色紙本，96.5 x 64.0厘米。

3. 凝重而奔突，1991
墨色紙本，128.6 x 64.5厘米。

4. 非漢字書法，1997
墨色紙本，137.7 x 67.1厘米。

韓天衡

　　韓天衡1940年生於上海，現爲上海畫院副院長，著名書法家、畫家、和篆刻家。其作品已被世界許多著名博物館收藏，包括大英博物館。韓天衡稱自己的畫室爲「百樂齋」。

5. 篆刻，1997
墨色與紅色紙本，68.2 x 95.2厘米。

> 好色之徒，瑤泉，甏父，克己，郁文山館，丁丑，百事順心，壯暮堂，味閒，朴印龍扃，味
> 閒，龍（肖形），味閒，佛（肖形），心是手非，南龍，貴彥，文壇巨匠、光耀千秋，牛氣
> 貫乎一生，龍（肖形），春洋，凌儁，萬古，味閒，千秋萬歲，方印增先，百樂齋

6. 李白[A.D. 701-762] 詩《巴女詞》，1997
墨色紙本（篆書），153.0 x 84.0厘米。
印：心畫，奇崛，韓，天衡，龍（肖形），安且康，吉祥，味閑，百樂齋，百樂，味閒，守白知黑

> 巴水急如箭，
> 巴船去若飛。
> 十月三千里，
> 郎行幾歲歸。
>
> 丁丑，翰天衡

何應輝

　　何應輝1946年生於四川省，六歲開始學習書法。文化大革命期間，曾作為知識青年下放農村接受勞動改造。即使在那樣惡劣的環境下，他仍堅持書法的學習。現為四川省書法家協會主席，中國書法家協會常務理事。

7. 山水畫稿，1992
墨色紙本，54.5 x 56.5厘米。
印：何氏，何氏之印，何應輝印

> 此圖實乃未完之稿。夜檢年來學畫舊紙，順乎其勢，略畫數行，聊以遣興，故充跋語。
> 或可應習作展之需歟。
> 壬申春初記於錦城古摩訶池上，老知青何氏應輝。

8. 白眼，1993
墨色紙本，60.5 x 75.7厘米。
印：射潮人

9. 白鶴，1995
墨色紙本，59.5 x 100.7厘米。
印：何印

10.「山中」、「海上」楹聯，1994
墨色紙本（行書），兩件，每件176.5 x 45.0厘米。
印：何氏之印，何應輝印，射潮人

山中歲月，
海上心情。

應輝

梁揚

梁揚1960年生於北京。1989年中國人民大學畢業，後在《中國書法》雜誌社任編輯。1990年赴法國巴黎大學攻讀藝術史及理論的博士學位，六年後回國任《中華兒女》雜誌副總編。他不僅是一位書法家，還是文學和京劇方面的學者。

11. 龐德[1885–1972]意象，1997
墨色紙本（草書），68.7 x 137.4厘米。
印：至眞，梁揚，聽其自然

幽靈，濕漉漉，花瓣。

劉炳森

劉炳森1937年生於天津農村：海自洼村，自稱"海村農"。出名于文化大革命後期出版的書法作品集《魯迅詩選》，以隸書聞名。現爲中國書法家協會副主席。

12. 龍慶峽神筆峰，1997
墨色紙本（隸書），179.0 x 96.3厘米。
印：無論漢魏，劉炳森印

輕露浮雲自卷舒，蒼天碧水兩平鋪。
會將神筆峰頭力，寫我胸中大隸書。

俚句龍慶峽神筆峰，雍陽劉炳森撰書

13. 遊山西村，1997
墨色綠紙（楷書），133.8 x 66.2厘米。
印：海村農，丁丑，劉炳森印

莫笑農家臘酒渾，豐年留客足雞豚。
山重水复疑無路，柳暗花明又一村。
蕭鼓追隨春社近，衣冠儉樸古風存。
從今若許閒乘月，拄杖無時夜扣門。

陸放翁[1125–1210]詩，劉炳森書

14. 客中作，1997

墨色棕紙本（草書），132.0 X 33.5厘米。

印：海村農，丁丑，炳森書畫

> 蘭陵美酒鬱金香，
> 玉碗盛來琥珀光。
> 但使主人能醉客，
> 不知何處是他鄉。
>
> 李白詩，劉炳森書

劉天煒

劉天煒 1954 年生於上海。1985 年獲波士頓美術學院碩士學位，其作品曾在中國、日本、和美國多次展出。

15. 詩經·考槃，1995

墨色紙本（行書），46.5 x 69.0厘米。

印：御龍氏，知白堂

> 考槃在澗，碩人之寬。獨寐寤言，永失弗諼。
> 考槃在阿，碩人之邁。獨寐寤歌，永失弗過。
> 考槃在陸，碩人之軸。獨寐寤宿，永失弗告。
>
> 《詩》·衛風·考槃。乙亥長夏，海上，知白堂書，劉天煒。

16. 離騷，1995

墨色紙本（草書），46.5 x 69.0厘米。

印：知白堂，劉氏

> 駟玉虬以乘鷖兮，溘埃風余上征。
> 朝發軔于蒼梧兮，夕余至縣圃。
> 欲少留此靈瑣兮，日忽忽其將暮。
> 吾令羲和弭節兮，望崦嵫而勿迫。
> 路曼曼其修遠兮，吾將上下而求索。
>
> 《離騷》句，天煒書

劉文華

劉文華1955年生於北京。1987 年畢業于首都師範大學書法專業。他多次獲得國家級書法展覽的獎勵，其中包括1989年第四屆全國書法展覽中獲獎作品《詠史》。

17. 詠史，1989
墨色紙本（隸書），130.0 x 66.0厘米。
印：劉文華印，璞光涂鴉

> 歷覽前賢國與家，成由勤儉破由奢。
> 何須琥珀方爲枕，豈得珍珠是始車。

> 李商隱 [A.D. 813–858] 詩一首。戊辰之秋，劉文華書於京都

劉正成

　　劉正成1946年出生於四川省。通過自學成爲著名的學者和書法家。他是聞名的《中國書法鑒賞大辭典》、《中國書法全集》、和當代書法主要刊物《中國書法》雜誌的主編。曾主持過多次全國書法展覽，其書法和觀念對當代中國書法有深刻影響。

18. 蘇軾天寺夜游，1997
墨色金線圖案紙本（行書），68.0 x 136.0厘米。
印：劉正成

> 元豐六年十月十二日，東坡貶黃州三年矣。夜解衣欲睡，月色入户，欣然赴行。念無與樂者，遂至承天寺，寺在湖北黃崗縣。尋張懷民，懷民名夢得，清河人，時亦正謫居黃州。懷民亦未寢，相與步于中庭。庭下如積水空明，水中藻荇交錯，蓋竹柏影也。何夜無月，何處無竹柏，但少閒人，如吾兩人爾。
> 東坡記承天寺夜遊，絕妙好辭也，正成

19. 泉聲，1997
墨色洒金紙本（行草書），66.0 x 130.0厘米。
印：松竹草堂，劉正成印章

> 濤聲得氣，泉聲得韻，氣與韻又豈可離異哉！正成

20. 春曉，1997
墨色紙本（草書），70.0 x 140.0厘米。
印：松竹草堂，劉正成印

> 春眠不覺曉，處處聞啼鳥。
> 夜來風雨聲，花落知多少。

> 孟浩然 [A.D. 689–740]《春曉》。丁丑中元，正成

21. 莘薳圖，1996
彩色紙本，131.8 x 33.8厘米。
印：松竹草堂，蜀西劉氏正成

> 甲子春，此茂正待開時，正成。

洛齊

　　洛齊1960年生於杭州，畢業於中國美術學院，後留該校任教授和編輯。他是「後現代書法」運動，即「書法主義」的主要代表人物之一。1993、1995和1997年曾三次組織「書法主義」展覽，影響了當代的書壇，與傳統的書法相對立。「書法主義」在「現代書法」的主體中更具有革新性。

22. 書法主義文本－情書之一，1990
彩色紙本，44.8 x 34.2厘米。

23. 書法主義文本－黑色主義之一，1990
彩色紙本，70.0 x 68.9厘米。

24. 書法主義文本－原句，1997
彩色紙本，68.0 x 68.0厘米。

歐陽中石

　　歐陽中石1928年生於山東省泰安。現爲首都師範大學教授。他不僅是著名的書法家，還是哲學、文學、和京劇方面的專家。1985年歐陽中石在該校首先創立了書法專業，把書法引入了高等教育領域。1995年又增設第一個書法博士班，使書法教育系統化和學術化。

墨色紙本（草書），138.0 x 69.0厘米。
印：歐陽中石印，欲老欲清

>　字勢若奔，手從情馳。
>　然必縈繞如章，簡化有度。
>　不乖使轉，不離其格。
>　庶近草書之趣邪。
>
>　中石學書一得

26. 行書有感，1997
墨色紙本（行書），138.0 x 69.0厘米。
印：歐陽中石印，欲老欲清

>　以正取勢，緩緩起動。
>　若天上行雲，似溪澗流水。
>　然務須氣和，神凝不失其儀。
>　抑是行書之旨也。
>
>　中石學書一得

邵岩

邵岩1960 年生於山東省。1995 年和1997 年分別獲得第六屆和第七屆全國中青年書法展覽一等獎。不同於其他現代書法家,邵岩没有放棄中國書法的文字形式。在對古典書法的探索中,他又吸取了西方藝術的觀念,以發現「自我」,實現其在「傳統和現代之間建立起高樓大廈」之願望。

27. 海,1991
墨色紙本,96.0 x 89.0厘米。

28. 圍,1991
墨色紙本,68.0 x 68.0厘米。
印: 邵岩之印

29. 無,1991
墨色紙本,68.0 x 68.0厘米。
印: 邵岩之印

30. 數點梅花天地心,1995
墨色紙本,276.0 x 48.0厘米。
印: 水墨世界,邵岩墨跡,山東漢子

沈鵬

沈鵬1931 年生於江蘇省。現爲中國書法家協會代主席,著名的書法家和藝術評論家,《人民美術出版社》總編輯。書法以行書和草書聞名于世。

31. 南行,1997
墨色紙本(行書),100.0 x 70.0厘米。
印: 沈鵬,餘

> 推窗漠漠隱平蕪,夾岸桃花有若無。
> 苔濕方知昨夜雨,頻年難得聽鵬鶿。

> 丁丑書舊作《南行》之一,沈鵬

32. 王之渙 [A.D. 688–742]詩二首,1997
墨色紙本(草書),兩件,每件,181.0 x 48.0厘米。
印: 春華秋實,餘,沈鵬,介居主

> 《登鸛雀樓》
> 白日依山盡,黃河入海流。
> 欲窮千里目,更上一層樓。

《涼州詞》

黃河遠上白雲間，一片孤城萬仞山。

羌笛何須怨楊柳，春風不度玉門關。

王之渙《登鸛雀樓》、《涼州詞》。丁丑盛夏極熱，沈鵬

孫伯翔

孫伯翔1934年生於天津。由于家庭出身地主，他在政治上曾受到迫害，上高中的權力被取消，在工廠裏當工人。然而，在不幸的遭遇下，孫伯翔把所有的業餘時間投入在書法技藝的完善上。現在，他已是著名的書法家，全國書法展覽的評委，天津市書法家協會副主席。

33. 像，1996
墨色紙本（楷書），69.5 x 68.8厘米。
印：孫伯翔，自有我在

北祖龍門石刻，方雄著稱於世。欲得方必得厚，始能爲雄。方雄之美，書家之妙，非鐫刻所能爲也。

余之淺識，伯翔

34. 「金石」、「冠裳」楹聯，1986
墨色棕紙本（楷書），兩件，每件266.0 x 38.0厘米。
印：孫伯翔印，師魏齋

金石璘鳴集中府，
冠裳肅穆振西雍。

伯翔

35. 「東山」、「大海」楹聯，1986
墨色棕紙本（行書），兩件，每件266.0 x 38.0厘米。
印：孫伯翔印

東山遺先賢文韜，
大海憑忠魂武威。

瞻拜威海劉公島北洋水師感懷。丙寅桂秋，孫伯翔謹書於師魏齋窗下。

36. 爲，1995
墨色紙本，89.5 x 70.7厘米。
印：孫伯翔印，自有我在

擬取孫其老之意，書此爲以應首屆國際現代書法雙年展。孫伯翔於瀚海水濱

37. 弘仁[1610–1664] 詩《題山水畫》，1994
墨色洒金紙本（行草書），圓形，直徑34.0厘米。
印：孫氏之璽，伯翔

> 飄泊終年未有廬，溪山蕭灑樹扶疏。
> 此時若遇雲林子，結個茅廬讀異書。
>
> 四大名僧之一弘仁《題山水畫》詩，伯翔書

孫曉雲

孫曉雲1955年生於江蘇省一個藝術家家庭，三歲開始學習書法。1986年獲得全國第二屆中青年書法展覽一等獎，在幾萬人參加的書法比賽中獲勝，之後她又多次獲獎。現爲南京畫院一級美術師。

38. 黃庭堅、韓愈、孫過庭論書，1995
墨色灑銀紙本（行草書），67.3×42.6厘米。
印：空境，孫曉雲書畫印，孫氏，水雲，孫曉雲，牧羊圖（肖形印）

> 張長史折釵骨，顏太師屋漏痕法，王右軍錐畫沙、印印泥，懷素飛鳥出林、驚蛇
> 入草，索靖銀鉤蠆尾，同是一筆法。心不知手，手不知心耳。
> 　黃庭堅 [1045–1105]《論書》
>
> 往時張旭善草書，不治他技，喜怒、窘窮、憂悲、愉佚、怨恨、思慕、酣醉、無
> 聊、不平，有動于心，必於草書焉發之。
> 　韓愈 [A.D. 768–824]《送高閑上人序》
>
> 知書道玄妙，必資神遇，不可以力求也。機巧必須心悟，不可以目取也。
> 　虞世南 [A.D. 558–638]《筆髓論》
>
> 初學分佈，但求平正，既知平正，務追險絕，既能險絕，復歸平正，初謂未及，
> 中則過之，後乃通會。通會之際，人書俱老。
> 　孫過庭 [A.D. 648–703]《書譜》
>
> 乙亥歲暮，書於南京，曉雲

39. 陶淵明詩二首[A.D. 372–427]，1996
墨色圖案紙（行書），兩件，每件21.8×44.2厘米。
印：空境，曉雲之印，孫氏，水雲，孫曉雲，牧羊圖（肖形印）

> 《停雲》一首並序
> 停雲，思親友也。樽湛新醪，園列初榮，願言不從，歎息彌襟。
> 靄靄停雲，濛濛時雨；
> 八表同昏，平路伊阻。
> 靜寄東軒，春醪獨撫；
> 良朋悠邈，搔首延佇。
> 停雲靄靄，時雨濛濛；
> 八表同昏，平陸成江。

有酒有酒，閒飲東窗；
願言懷人，舟車靡從。
東園之樹，枝條再榮；
競朋新好，以怡余情。
人亦有言，日月于征；
安得促席，說彼平生？
翩翩飛鳥，息我庭柯；
斂翮閒止，好聲相合。
豈無他人，念子實多；
願言不獲，抱恨如何。

《時運》一首並序
時運，游暮春也。春服既成，景物斯和，偶影獨游，欣慨交心。
邁邁時運，穆穆良朝；
襲我春服，薄言東郊。
山滌餘靄，宇暖微霄；
有風自南，翼彼新苗。
洋洋平澤，乃漱乃濯；
邈邈遐景，載欣載矚。
稱心而言，人亦易足；
揮茲一觴，陶然自樂。
延目中流，悠想清沂；
童冠齊業，閒詠以歸。
我愛其靜，寤寐交揮；
但恨殊世，邈不可追。
斯晨斯夕，言息其廬；
花藥分列，林竹翳如。
清琴橫床，濁酒半壺；
黃唐莫逮，慨獨在余。

丙子之春，清明時節，嘗書陶淵明詩四言詩二首，曉雲

40. 歷代禪詩八首，1997
墨色紙本（楷書），24.8×44.4厘米。
印：空境，孫，曉雲

菩提本無樹，明鏡亦非臺。
本來無一物，何處惹塵埃。
　　唐・惠能 [A.D. 638-713]《示法詩》

日用事無別，惟吾自偶偕。
頭頭非取舍，處處勿張乖。
朱紫誰為號，青山絕點埃。
神通並妙用，運水及搬柴。
　　唐・龐蘊《雜詩》

擁毳對芳叢，由來趣不同。
發從今日白，花是去年紅。
艷冶隨朝露，馨香逐晚風。
何須待零落，然後始成空。
　　　五代・文益[A.D. 885-958]《示法詩》

因僧問我西來意，我話山居不記年。
草履只栽三個耳，麻衣曾補兩番肩。
東菴每見西菴雪，下澗常流上澗泉。
半夜白雲消散後，一輪明月到床前。
　　　宋・靈澄《山居》

山前一片閒田地，叉手叮嚀問祖翁。
幾度賣來還自買，為憐松竹引清風。
　　　宋・法演[D. 1104]《開悟》

雪深三尺閉柴荊，歲晚無心打葛藤。
立雪堂前人不見，秀雲峰似白頭僧。
　　　元・惟則《師子林即景》六首之一

久懷獅乳到香林，果見幽寒乳澤深。
溪口忽崩三峽浪，殿前高鎖七峰陰。
雲煙古道奔軍騎，晝夜空堂聽梵琴。
個是憨師真說法，天風不斷海潮音。
　　　明・戒顯《五乳雨後聽泉》

禪宮寂寂白雲封，枯坐蒲團萬慮空。
定起不知天已暮，忽驚身在明月中。
　　　清・敬安[1841-1921]《出定吟》

丁丑年書歷代禪詩八首於南京，曉雲

王冬齡

　　王冬齡1945年生於江蘇省。1981年畢業於中國美術學院，後留校任書法教授。其書法作品多次獲獎，1989年曾在明尼蘇達大學教授書法，在美期間他學習了現代西方藝術，並受其影響，對傳統的書法進行了革新。

41. 意向徐渭，1986
墨色棕紙本，100.0 x 67.5厘米。
印：抽象

42. 無為，1997
墨色灑金紙本（篆書），36.3 x 50.1厘米。
印：東皋，王冬齡印

43. 神秘之門, 1997
墨色紙本, 78.5 x 68.5厘米。
印: 長樂, 爲學年壽, 冬齡, 王冬齡印, 冬齡之印, 悟齋, 東皋, 眠鷗樓, 王冬齡印

44. 舞, 1988
彩色紙本, 55.3 x 53.3厘米。
印: 王冬齡印

45. 杜甫詩《觀公孫大娘弟子舞劍器行·(並序)》, 1987
墨色紙本(草書), 四條屏, 每件235.5 x 53.8厘米。
印: 大雅, 杭州, 眠鶴樓, 王冬齡印

大歷二年十月十九日, 夔州別駕元持宅, 見臨潁李十二娘舞劍器, 壯其蔚跂。問其所師? 曰: "余, 公孫大娘弟子也"。開元三載, 余尚童稚, 記于郾城觀公孫氏舞劍器渾脫, 瀏灕頓挫, 獨出冠時。自高頭宜春梨園二伎坊內人, 洎外供奉, 曉是舞者, 聖文神武皇帝初, 公孫一人而已! 玉貌錦衣, 況余白首! 今茲弟子, 亦匪盛顏, 既辨其由來, 知波瀾莫二。撫是感(慷)慨, 聊爲《劍器行》, 往者吳人張旭善草書、書帖, 數嘗於鄴縣見公孫大娘舞西河劍器, 自此草書長進, 豪蕩感激, 即公孫可知矣!
昔有佳人公孫氏, 一舞劍器動四方。
觀者如山色沮喪, 天地爲之久低昂。
㸌如羿射九日落, 嬌如群帝驂龍翔。
來如雷霆收震怒, 罷如江海凝清光。
絳脣珠袖兩寂寞, 晚有弟子傳芬芳。
臨潁美人在白帝, 妙舞此曲神揚揚。
與余問答既有以, 感時撫事增惋傷。
先帝侍女八千人, 公孫劍器初第一。
五十年間似反掌, 風塵澒洞昏王室!
梨園弟子散如煙, 女樂餘姿映寒日。
金粟堆前(南)木已拱, 瞿唐石城草蕭瑟。
玳弦(筵)急管曲復終, 樂極哀來月東出。
老夫不知其所往, 足繭荒山轉愁疾!

丁卯元月, 王冬齡書

王學仲

王學仲1925年生於山東省。現爲天津大學教授, 中國書法家協會副主席, 天津市書法家協會主席。著名書法家、畫家、和詩人, 對書法理論有很多著述。

46. 垂揚飲馬, 1979
彩色紙本, 85.9 x 68.6厘米。
印: 夜泊

戊辰, 夜泊

王鏞

　　王鏞1948年生於北京。文化大革命期間曾到內蒙古插隊六年,在此期間仍堅持學習書法,這段生活經歷影響了他的藝術風格。1979年考入中央美術學院研究院,現爲該校教授,著名的書法家、畫家、和篆刻家。

47. 「八字」、「六朝」楹聯,1992
墨色紙本(行草書),231.0 x 49.0厘米。
印:王鏞之璽,戊子生

　　八字碑題韓玉父,
　　六朝人勝沈東陽。

　　王鏞

48. 海爲龍世界,1996
墨色紙本(草書),173.0 x 190.0厘米。
印:太原王氏,夕陽樓

49. 杜甫詩一首,1990
墨色紙本(草書),138.0 x 58.0厘米。
印:王鏞所作

　　江漢曾爲客,相逢每醉還。
　　浮雲一別後,流水十年間。
　　歡笑情如舊,蕭疏鬢已斑。
　　何因不歸去,淮上有青山。

　　鏞

50. 山水畫,1997
彩色紙本,138.0 x 69.0厘米
印:晉人,WY,王鏞,山水師意

　　鐵畫皴擦帶老霜,倫將宿墨寫新涼。
　　披圖細認昔游處,一徑苔痕綠上窗。

　　畫意何妨向外搜,傾來老墨記神遊。
　　漫說紙上無顏色,顏色多時本色休。

　　右題畫舊作兩首,歲次丁丑夏伏,大雨初收,於鼎攫,王鏞

51. 篆刻,1995-1996
彩色紙本,31.5 x 40.6厘米。

　　鳥瘦花肥,晉專吟室印,太原王氏,夕陽樓

王友誼

王友誼1949年生於北京市平谷縣，1985年考入首都師範大學書法專業，曾多次在全國書法展覽中獲獎，現爲專業書法家、全國中青年書法展覽的評委。

52. 丁輔之[1878-1949]詩四首，1997
墨色棕紙本（篆書），271.0 x 69.0厘米。
印：有一

行年五十不爲老，藝事求工朝夕爲。
喜有良朋時益我，心傳更以古人師。

喜逢冬至一陽回，相對幽花逐酒來。
此夜農郊風又雪，明年豐獲不爲災。

遊觀獨喜入明山，近日行來雙足艱。
爲問古人不知處，家無僕御閉門關。

東風細雨二三日，爲鼓泉塘子午濤。
如雨如風如萬馬，洋洋觀止月兒高。

集詩四首，友誼

53. 十二生肖象形文字，1997
墨色紙本（篆書），103.8 x 69.0厘米。
印：王友誼作篆之印

鼠牛虎兔龍蛇馬羊猴雞狗豬。
錄十二生肖象形文字，「鼠」字甲骨文所無，擬以小篆代之，友誼

54. 「師還」、「月散」楹聯，1995
墨色紙本（篆書），兩件，每件261.0 x 51.5厘米。
印：友誼

師還一旅，
月散三邊。

《散盤》銘文集聯「師還一旅，月散三邊」，歲次乙亥年初之時，篆於京東田園小舍，友誼

張道興

張道興1935年生於河北省學者家庭，著名書法家、畫家、和篆刻家。其作品在全國藝術展覽中曾多次獲獎，現爲一級美術師，全國繪畫和書法展覽的評委。

55. 水上人家，1995
彩色紙本，67.0 x 67.0厘米。
印：張道興印，文貴堂

56. 日日，1997
墨色紙本（行草書），45.0 x 67.0厘米。
印：張，張道興印，張道興印章

　　日日春光鬥日光，
　　山城斜路杏花香。
　　幾時心緒渾無事，
　　得及游絲百尺長。

　　李商隱詩一首，丁丑，道興書

57. 秤魚，1995
彩色紙本，圓形，直徑40.0厘米。
印：張道興印，張

58. 道德經，1995
墨色紙本（行書），30.0 x 64.0厘米
印：張道興印信，張

　　大成若缺，其用不弊。
　　大盈若沖，其用不窮。
　　大直若詘，大辯若訥。
　　大巧若拙，其用不屈。
　　躁盛寒，靜盛熱。
　　可以為天下正。

　　老子語，乙亥歲次之秋，道興

59. 蘇軾語，1990
彩色紙本，34.0 x 34.0厘米。
印：萬涂一轍，張，文貴堂，道興之印，張，儉園，張道興印，張道興印信

　　嘗有三老人相遇，或問之年。一人曰：「吾年不可記，但憶少年時，與盤古有舊」。
　　一人曰：「海水桑田時下一籌，爾來籌以滿三間屋」。一人曰：「吾所食蟠桃，棄其
　　核于昆侖山下，如今已與昆侖齊矣」。以余觀之，三老者，與浮游朝菌何異哉！

　　東坡居士語，道興漫。

張強

　　張強1962年生於山東省。現為山東藝術學院副教授，作為現代書法理論和實踐的倡
導者，他組織並參與了多次現代書法展覽，主要著作有：《現代書法學綜論》和《遊戲中
破碎的方塊－後現代主義與當代書法》。

60. A–B 模型 18，6 號，1996
墨色紙本，180.0 x 96.0厘米。
印：The Report of Zhang Qiang's Study of the Trace（張強蹤跡學報告）

周慧珺

　　周慧珺1939年生於浙江省。現爲上海畫院一級美術師。七十年代末期,以出版《魯迅詩歌》而聞名。年輕時,她因患疾病,行路艱難,但卻造就了她不肯向命運屈服的倔強個性,其筆端體現了剛毅、雄強的書風。

61. 正氣內存,邪不可干,1994
綠色紙本(行草書),130.0×32.5厘米。
印:心畫,周慧珺

　　周慧珺書

62. 中堂,1994
墨色綠紙本(行草書),64.0×61.5厘米。
印:心畫,周慧珺,鳥(肖形)

　　頗有清香凝畫戟,
　　翩然彩裙放扁舟。

　　甲戌新秋,周慧珺書。

63. 「文章」、「議論」楹聯,1995
墨色紙本(行草書),兩件,每件136.0×23.0厘米。
印:慧珺

　　文章散作生靈福,
　　議論吐爲仁義辭。

　　慧珺書

64. 陋室銘,1997
棕色紙本(楷書),67.0×51.0厘米。
印:心畫,慧珺

　　山不在高,有僊則名。
　　水不在深,有龍則靈。
　　斯是陋室,惟吾德馨。
　　苔痕上階綠,草色入簾青。
　　談笑有鴻儒,往來無白丁。
　　可以調素琴、閱金經。
　　無絲竹之亂耳,無案牘之勞形。
　　南陽諸葛廬,西蜀子雲亭。
　　孔子曰:「何陋之有」!

　　右錄劉禹錫《陋室銘》,丁丑盛夏,周慧珺書於高安樓

SELECTED BIBLIOGRAPHY

IN ENGLISH

Billeter, Jean François, *The Chinese Art of Writing* (New York, 1990).

Barnhart, Richard, "Wei Fu-jen's Pi Chen Tu and the Early Texts on Calligraphy," *Archives of the Chinese Art Society of America* 18 (1964):13–25.

Chaves, Jonathan, "The Legacy of Ts'ang Chieh: the Writing Word as Magic," *Oriental Art* 2 (1979):200–15.

Chang, Ch'ung-ho, and Hans H. Frankel, *Two Treatises on Calligraphy* (New Haven, 1995).

Chang, Long-yien, *Four Thousand Years of Chinese Calligraphy* (Chicago, 1990).

Farrer, Anne, *The Brush Dances and Ink Sings: Chinese Painting and Calligraphy from the British Museum* (exh. cat., Hayward Gallery, London, 1990).

Fong, Wen, "Ch'i-yun-sheng-tung: 'Vitality, Harmonious, Manner, and Aliveness,'" *Oriental Art* 12, no. 3 (autumn 1966):159–64.

_____, *Beyond Representation: Chinese Painting and Calligraphy, 8th–14th Century* (New York, 1992).

_____, et al., *Images of the Mind: Selections from the Edward L. Elliott Family and John B. Elliott Collections of Chinese Calligraphy and Painting at the Art Museum, Princeton University* (exh. cat., 1984).

_____, and James C. Y. Watt, *Possessing the Past: Treasures from the National Palace Museum, Taipei* (New York and Taipei, 1996).

Fu, Marilyn Wong, and Shen C.Y. Fu, *Studies in Connoisseurship: Chinese Painting from the Arthur M. Sackler Collection in New York and Princeton* (Princeton, 1973).

Fu, Shen C. Y., "Huang T'ing-chien's Calligraphy and His Scroll for Chang Ta-t'ung: A Masterpiece Written In Exile," Ph.D. diss., Princeton University, 1976.

_____, et al., *Trace of the Brush: Studies in Chinese Calligraphy* (New Haven, 1977).

Hay, John, "The Human Body as a Microcosmic Source of Macrocosmic Values in Calligraphy," in *Theories of the Arts in China*, ed. Susan Bush and Christian Murch (Princeton, 1983): 385–404.

Keightley, David N., "Art, Ancestors, and the Origins of Writing in China" *Representations* 56 (autumn 1996):68–95.

Ledderose, Lothar, *Mi Fu and the Classical Tradition of Chinese Calligraphy* (Princeton, 1979).

_____, "Chinese Calligraphy: Its Aesthetic Dimension and Social Function," *Orientations* (October 1986):16.

152

Lee, Sherman E., *A History of Far Eastern Art,* 5th ed. (New York:, 1994).

Moran, Patrick E., *Three Smaller Wisdom Books (Lao Zi's* Dao De Jing, *the* Great Learning *[Da Xue], and* Doctrine of the Mean *[Zhong Yong])* (Lanham, Md., 1993).

Mote, Frederick W., *Calligraphy and the East Asian Book* (Boston, 1989).

Murray, Julia K., *Last of the Mandarins: Chinese Calligraphy and Painting from F. Y. Chang Collection* (exh. cat., Arthur M. Sackler Museum, Harvard University Art Museums, 1987).

Sturman, Peter Charles, *Mi Fu: Style and the Art of Calligraphy in Northern Song China* (New Haven, 1997).

Sullivan, Michael, *The Three Perfections: Chinese Painting, Poetry, and Calligraphy* (New York, 1980).

Tseng, Yu-ho, *A History of Chinese Calligraphy* (Hong Kong, 1993).

Tsien, T. H., *Written on Bamboo and Silk: The Beginnings of Chinese Books and Inscriptions* (Chicago, 1962).

IN CHINESE

An Qi, *Mo Yuan Hui Guan Lu, Guoxue Jiben Congshu* (A Comprehensive Record of Ink Acquaintances: Catalogue of An Qi's Collection of Calligraphy and Painting), vol. 155, 2 (Taibei, 1986) 111–13.

Chen Fangji, *Shufa Meixue Sixiangshi* (History of Calligraphic Aesthetic Thought) (Zhengzhou, 1994).

Chen Zhenlian, *Shufa Jiaoyu Xue* (Study of Calligraphic Education) (Hangzhou, 1992).

_____, *Xiandai Zhongguo Shufashi* (History of Contemporary Calligraphy) (Zhengzhou, 1993).

Ding Mengzhou, *Zhongguo Shufa Yu Xiantiao Yishu* (Chinese Calligraphy and Graphic Art) (Hefei, 1994).

Gu Gan, *Xiandan Shufa Goucheng* (Structure of Modern Calligraphy) (Beijing, 1987).

_____, *Xiandai Shufa Sanbu* (Three Stages of Modern Calligraphy) (Beijing, 1990).

Hua Rende, *Nanbei Shupai Lun: Beibei Nantie Lunzhu* (Northern and Southern Schools of Calligraphy: Discussions of Northern Stele and Southern Manuscripts) (Shanghai, 1997).

Hong Pimo, *Gudian Shufa Lilun* (Ancient Calligraphic Theory) (Nanjing, 1987).

Hsiung Ping-ming, *Zhongguo Shufa Lilun Tixi* (Theoretical System of Chinese Calligraphy) (Hong Kong, 1984).

"Jiakuai Gaige Fanrong Chuangzuo: Liu Yi Tongzhi Jiu Diwujie Quanguo Shufa Zhanlan Da Benkan Jizhe Wen" (Accelerate Reform, Enrich Creativity: Comrade Liu Yi Responds to Our Reporter's Questions on the Fifth All-China Calligraphy Exhibition), *Shufa* (1992, no. 5):4–6.

Jiang Chengqing, *Zhongguo Shufa Sixiangshi* (History of Chinese Calligraphic Thought) (Zhengzhou, 1994).

Jin Kaicheng, *Shufa Yishu Meixue* (Aesthetics of the Art of Calligraphy) (Beijing, 1995).

Jin Xuezhi, *Shugai Pingzhu* (Critiques and Notes on Calligraphy) (Shanghai, 1990).

_____, *Zhongguo Shufa Meixue* (Aesthetics of Chinese Calligraphy) (Nanjing, 1994).

Lang Shaojun, "Hou Xiandai Yuanze: Yetan Xiandai Shufa" (Postmodern Principles: Another Discussion of Modern Calligraphy), *Shufa Yanjiu* 46 (1991, no. 4):11–17.

_____, in "Shao Yan Shufa Chuangzuo Zuotanhui Fayan Xuandeng" (Selections from Speeches at the Conference on Shao Yan's Calligraphy), *Zhongguo Shufa* (1993, no. 3):50.

Li Shilao, in "Shao Yan Shufa Chuangzuo Zuotanhui Fayan Xuandeng" (Selections from Speeches at the Conference on Shao Yan's Calligraphy), *Zhongguo Shufa* (1993, no. 3):49.

Li Xianting, "Xiandai Shufa Zhiyi: Cong 'Shuhua Tongyuan' Dao 'Shuhua Guiyi'" (Questioning Modern Calligraphy: From 'Painting and Calligraphy with a Common Source' to 'Unification of Painting and Calligraphy'), *Shufa Yanjiu* 46 (1991, no. 4):25.

Lidai Shufa Lunwen Xuan (Selected Calligraphic Essays throughout History) (Shanghai, 1980).

Lu Chen, in "Shao Yan Shufa Chuangzuo Zuotanhui Fayan Xuandeng" (Selections from Speeches at the Conference on Shao Yan's Calligraphy), *Zhongguo Shufa* (1991, no. 3):2–4.

Qiu Zhenzhong, *Shufa Yishu Yu Jianshang* (Art and Appreciation of Calligraphy) (Taibei, 1994).

"Saikele Bei Shufa Jingsai Jianjie" (Brief Introduction to the Sackler International Calligraphy Competition), *Zhongguo Shufa* (1991, no. 2):43.

Shen Yinmo, *Shufa Luncong* (Collected Essays on Calligraphy) (Shanghai, 1979).

_____, "Shufa Lun" (On Calligraphy), in *Xiandai Shufa Lunwen Xuan* (Shanghai, 1980) 1–26.

Shufa Zhuyi Wenben: 1993–1996 (Essays on Calligraphyism), ed. Luo Qi (Guangxi, 1997).

Yang Zhaoling, "Xiandai Shufa De Jueqi Jiqi Fazhan" (Blossoming of Modern Calligraphy and Its Development), *Xiandai Shufa* (1994, no. 3):27.

Ye Xiushan, *Shufa Meixue Yinlun* (Introduction to the Aesthetics of Calligraphy) (Beijing, 1987).

Yu Jianshi, *Shufa Zhangfa Daoyin* (Guide to Calligraphy Composition) (Tianjin, 1990).

Wang Nanming, *Lijie Xiandan Shufa* (Understanding Modern Calligraphy) (Nanjing, 1994).

Wang Xizhi, "Ti Wei Furen Bizhentu" (Colophon to Madam Wei's "Bizhentu"), in *Lidai Shufa Lunwen Xuan*, vol. 1 (Shanghai, 1980) 26–27.

Wo Xinghua, *Zhongguo Shufa* (Chinese Calligraphy) (Shanghai, 1995).

Zhang Qiang, *Xiandai Shufaxue Zonglun* (Overview of Modern Calligraphy) (Shangdong, 1993).

Zhang Yanyuan, *Lidai Minghua Ji* (Record of Famous Paintings Throughout History), completed 847 (Beijing, 1985).

Zhang Yiguo, *Shufa: Xinling De Yishu* (Calligraphy: the Art of Heart and Soul) (Beijing, 1991; Taibei, 1992).

Zhongguo Shufa Da Zidian (Dictionary of Chinese Calligraphy) (Hong Kong, 1984).

Zhongguo Shufa Jianshang Da Cidian (Dictionary of the Appreciation and Examination of Chinese Calligraphy) (Beijing, 1989).

Zhongguo Shufa Zhuanke Jianshang Cidian (Dictionary of the Appreciation of Chinese Calligraphy and Seals) (Beijing, 1989).

Zhongguo Shuhua Jianshang Cidian (Dictionary of the Appreciation of Chinese Painting and Calligraphy) (Beijing, 1988).

Zhou Junjie, "Dihuo Zhu Zhenhun: Ji Quanguo Meikuang Shufa Yanjiuhui Jiqi Huizhang Liang Dong" (The True Spirit Wrought of Earth's Fire: A Record of the All-China Coal Miners' Association for the Study of Calligraphy and Its President, Liang Dong), *Zhongguo Shufa* (1991, no. 4):49–58.

Zong Baihua, "Zhongguo Shufa Li De Meixue Sixiang" (Aesthetic Thought in Chinese Calligraphy), in *Xiandai Shufa Lunwen Xuan* (Shanghai, 1979) 96–117.

Zou Tao, "Gui Zai Shenzao Qiu Qi Tong: Qiantan Wang Youyi Shufa De Tansuo" (Deep Training in Search of Profound Understanding Is the Most Important Thing: An Overview of Wang Youyi's Calligraphy and Exploration), *Zhongguo Shufa* (1991, no. 3):48–49.

PRINCIPAL SPECIALIZED PERIODICALS

Zhongguo Shufa (Chinese Calligraphy). Beijing, 1982–.

Shufa Yanjiu (Calligraphy Study) and Shufa (Calligraphy). Shanghai, 1979–.

Shufa Bao (Calligraphy News). Hubei Province, 1984–.

Zhonguo Shuhua Bao (Chinese Calligraphy News). Tianjin, 1982–.

Shupu (The Method of Calligraphy). Hong Kong.

Shufa Daobao (Calligraphy Guide News). Henan Province.

Shufa Congkan (Calligraphy Magazine). Beijing, 1981–.

Xiandai Shufa (Modern Calligraphy). Guangxi Province.

PHOTO CREDITS

Palace Museum, Beijing, FIG. II, IV

Chinese Calligraphy Dictionary (Zhongguo Shufa Da Cidian, Hong Kong, 1976), FIG. 5B, 8B, 19A, 19B, 27A, 30B, 30C, 30D, 30E, 40A

Robert Hatfield Ellsworth, *Later Chinese Painting and Calligraphy, 1800–1950* (New York, 1987), FIG. III, XII, XIII

Archaeological Research Institute, Gansu, FIG. VII

Bill Jacobson, p. 126

Liaoning Provincial Museum, FIG. XV

Courtesy Liu Tianyu, FIG. XXX

Dwight Primiano, CAT. 1–47, 49–64, PL. 1, 3–4, 7

San Francisco Museum of Modern Art, FIG. XXIX

Gregory W. Schmitz, FIG. V, XII, XIII, XVIIa–b, XXXI

Shanghai Museum, FIG. XVIII, XXVII, 51A

Courtesy Su Yuanzhang, FIG. XXV

National Palace Museum, Taibei, FIG. 10B

Wang Yan, CAT. 48, PL. 2, 5–6, 8–11

Courtesy Xu Futong, FIG. XXVIII

Courtesy Zhang Dawo, FIG. XXIV

Courtesy Zhang Hongyuan, FIG. XXXI